D1300081

MODERN ROMANCE

David *Levinthal*

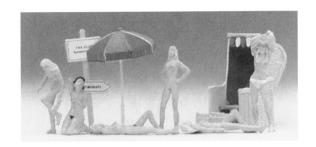

David *Levinthal*

THE
GREAT PRETENDER

An Essay by

Eugenia Parry

THE GREAT PRETENDER

At thirty he believes that his childhood—frustrated, silent, sedentary, and mad—is still with him; the company of other adults, the claims of his mistress pull him momentarily away, out of it, but he falls back as soon as he finds himself alone again.

JEAN-PAUL SARTRE, *The Family Idiot*

We are not...in danger of lacking meaning; quite to the contrary, we are gorged with meaning and it is killing us. As more and more things have fallen into the abyss of meaning, they have retained less and less of the charm of appearances. There is something secret in appearances, precisely because they do not readily lend themselves to interpretation. They remain insoluble, indecipherable....I am...seeking to regain a space for the secret, seduction being simply that which lets appearance circulate and move as a secret.

JEAN BAUDRILLARD, *The Ecstasy of Communication*

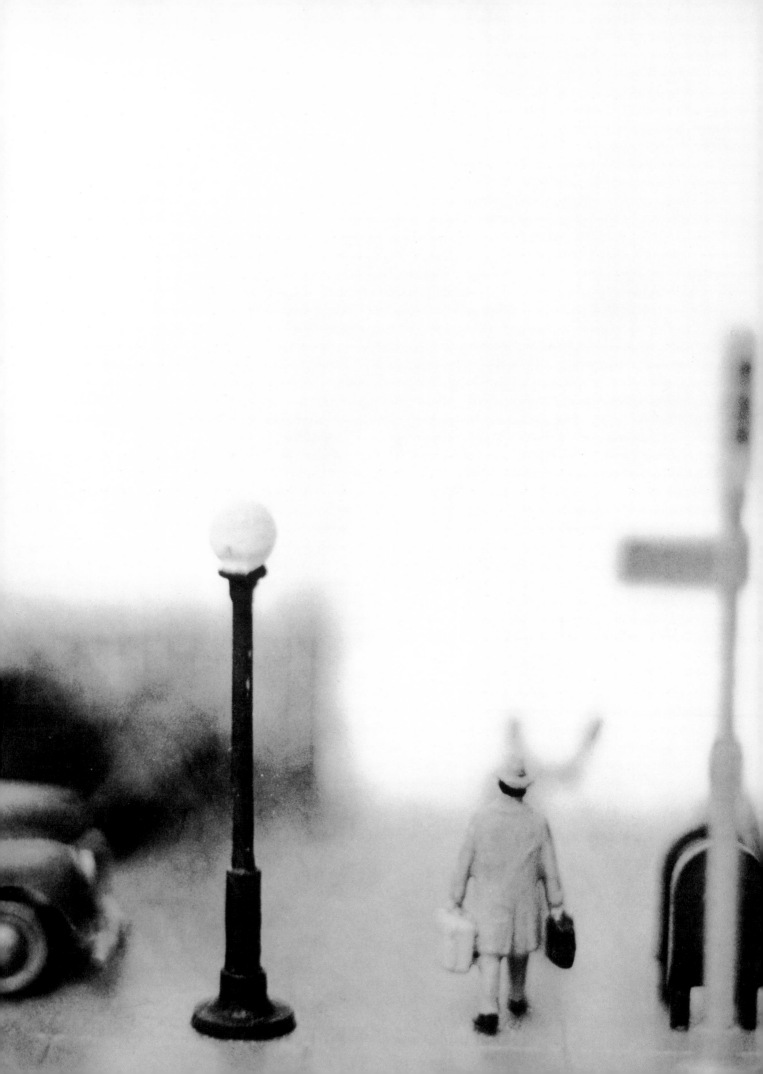

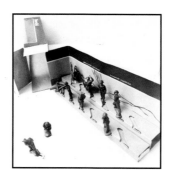

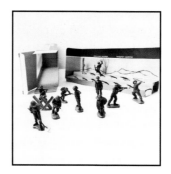

STRANGER

In 1983 David Levinthal, thirty-four, was stuck. He'd been young when he published his first photographic book; now he was beginning to wonder if his relation to the acclaim for *Hitler Moves East* wasn't some kind of fluke.[1] His imaginative gift had dried up. "As I get older the pain becomes more intense; . . . time seems more important, . . . seems to be running out," he complained to his journal.[2] The momentum was gone. He buried the panic.

Cover-up was a specialty: at nineteen, bleeding from colitis, "a very unsexy disease," he'd memorized the site of every restroom on the Stanford University campus.[3] In his family of hard-driving Jews, brilliant and accomplished in physics, law, academia, business, medicine, and finance, Nobel laureates arrived for cocktails and stayed for dinner. Nothing was important in such circles unless the aim was abundantly serious. Even his paternal grandmother, Rose, paragon of high standards, was a champion golfer. "In my family, being successful was taking the *easy* way out,"[4] he'd quip to his friends. He meant to amuse, but it conveyed his anguish.

He never had to worry about financial support: "Be a ski-bum, if you want."[5] They meant it. Their love for him, for whatever he chose to do, was unbridled. Yet, the "guilt-ridden Jewish child"[6] submitted to wordless pressure and got a degree from M.I.T. business school, after which he cofounded and codirected a successful public relations firm in Menlo Park, California. "How about this kind of serious?" he seemed to be asking them.[7]

New Venture Communications not only bored him, he'd all but forgotten what he really cared about. The fact of this plunged him into despair. After a day at the office, he'd return home, swallow some soup and saltines, turn on KFAT out of Gilroy, and sit alone at his table, drowning in Shark Vegas: "You hurt me! Now your flesh lies rotting in hell!"

It was an old habit, retreating to a corner. Happily immobile, consumed by a mental cinema, he populated fantasies with impossible loves: real women–Holly, Linda, Blake, Anne, Tina, Danielle, and many others. There were gorgeous fictions as well–pale, long-legged Kelly Green, renegade redhead of crime comics, "graphic novels," so-called, that bore her name.[8] As he mused, haunted solitaries, like himself, joined these objects of desire, enacting scenes of painful longing, in small, obscure spaces.

UNDER MY THUMB

When I opened the door and walked into the musty silence of the little waiting room there was the usual feeling of having been dropped down a well dried up twenty years ago to which no one would come back ever. The smell of old dust hung in the air as flat and stale as . . .[9]

It started without his exactly willing it. One night he took a mat knife and started cutting into shoe boxes, cardboard, and foam core. Joining the pieces at the corners with tape, he began to arrange them to suggest a miniature office, hotel room, pool hall, foyer, or a narrow corridor viewed through a doorway. He was intrigued by what emerged without much conscious direction and by how little he needed to produce an effect.

His big hands were clearly unsuited to the task of fashioning what the reveries called forth. Completely absorbed, he had no difficulty. Besides, he was satisfied with constructions of the crudest sort. Paste-togethers, they were for himself alone, nothing he would have wanted to show family or friends. Nor were they anything that fanatics of the small, among model-railroad hobbyists or dollhouse aficionados, would have admired for their intricacy or seamless true-to-life detail.

The spaces were suggestive, fragments of larger unseen wholes. Excited, feeling his way, he contrived diners, motel exteriors, garden apartments. He was in love with their promise of narrative. It inspired him with a plan: all he needed to do was make the sets look good enough to be photographed.[10]

They had to contain certain specifics. From hobby shops he bought a selection of wallpaper in tiny designs—he liked "Dauphine," a pink French stripe, but he used many others. Plagued by a bleeding gut, he had a fondness for the refuge of bathrooms; for a miniature of one of these, he cut a shower curtain from clear acetate and decorated it with colored-dot adhesives. He cut up pink dollhouse flooring, called "Nostalgia,"[11] that simulated bathroom tiles. He used a larger black-and-white or red-and-white check for pavement alongside what took shape as a motel swimming pool, a newspaper kiosk, a restaurant, or a forties-style jive joint. He got hexagonal tile for subway stops and plastic brick for streets.

Like the night-shrouded California house where he initiated these tabletop theaters, nearly all were nocturnal. It was essential to distinguish between the kinds of artificial light that each scene required. He put dollhouse lamps (standing and desktop), with hatlike shades, into the hotel rooms or lobbies. He bought tiny, round-globed street lamps and positioned them at his fabricated curbs. The light sources had to spot, graze, or flood the spaces, selectively, to convey the dramas he was after.

He couldn't have explained what these dramas were, except that many seemed to issue from the past, from the forties and fifties, years of his infancy and childhood. They had the feeling of scenes from *The Stranger* by Camus, in which he'd found himself mirrored utterly. As he created lonely, darkening streets, it was as if Camus's hero, Meursault, were speaking through him:

The sky had changed again; a reddish glow was spreading up beyond the housetops. As dusk set in, the street grew more crowded. People were returning from their walks. . . . After some minutes the local picture houses disgorged their audiences. I noticed that the young fellows coming from them were taking longer strides and gesturing more vigorously than at ordinary times; doubtless the picture they'd been seeing was of the wild-West variety. Those who had been to the picture houses in the middle of the town

1.

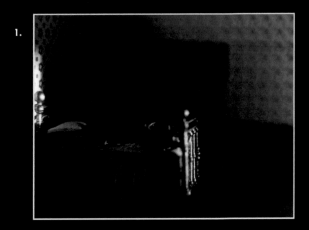

2.

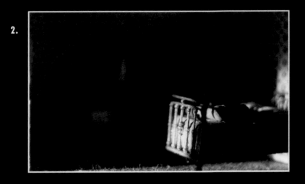

3.

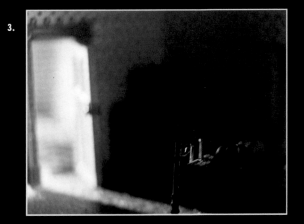

came a little later, and looked more sedate, though a few were still laughing. On the whole, however, they seemed languid and exhausted. Some of them remained loitering in the street under my window. A group of girls came by, walking arm in arm. The young men under my window swerved so as to brush against them, and shouted humorous remarks, which made the girls turn their heads and giggle. . . .

Just then the street lamps came on, all together, and they made the stars that were beginning to glimmer in the night sky paler still. I felt my eyes getting tired, what with the lights and all the movement I'd been watching in the street. There were little pools of brightness under the lamps, and now and then a streetcar passed, lighting up a girl's hair, or a smile, or a silver bangle.

Soon after this, as the streetcars became fewer and the sky showed velvety black above the trees and lamps, the street grew emptier, almost imperceptibly, until a time came when there was nobody to be seen and a cat, the first of the evening, crossed, unhurrying, the deserted street.[12]

He wasn't telling Camus's story, or any story, in particular. But a sense of impending situations seemed to result from the slightest spatial inflections that he created. Inspired by the notion, he started keeping a sketchbook and called it *Modern Romance*.[13] It was dedicated to what had become a project, though he still wasn't sure what that meant.

The secrecy of small spaces obsessed him. Unable to draw "to save himself,"[14] nonetheless, he drafted pages of calculations: the angle of a banister; a hotel room with an attached vestibule; apartment buildings seen from above; a railway overpass viewed from below; or how a nightclub looked from the vantage point of the piano player.[15] He became a student of psychological geometries. Space was flexible, and, as he discovered to his satisfaction, soulful. He mapped it endlessly, distinguishing between the emotions produced by an office corridor and those of a hospital or mansion.

He enhanced the geometry with light's mercurial moods. A pattern of venetian blinds in windows and doors, achieved with strips of transparent tape, threw stripes on the walls, turning the three-dimensionality of a room into a kind of urban prison, warding off fictional sunshine.

Beyond the little hallway the room widened towards a pair of windows through which the evening sun slanted in a shaft that reached almost across the bed and came to a stop under the . . .[16]

Hidden pin lights,[17] taped to the cardboard and directed under dollhouse lamps, gave them a dour electrical glow, suggesting a poetics of alienation and estrangement. The places were insomnious, with eyes, ears, and infinite patience. They might be waiting for the return of a departed inhabitant, or conceal the body of a victim, or shroud a lonely young woman, staring at empty walls. The paintings of Edward Hopper come to mind, as does Walker Evans's affinity for abandoned habitations. Hopper's multiple angles and receding rooms had been an important point of departure, but the fabricator's lighting soon replaced the painter's psychological restraint with a new kind of emotional heat. Evans's classic American documents were obvious prototypes, but their detachment

was too cool to be inspiring.[18]

He liked confined spaces that were emblematically mysterious, and from his perspective as a child, had been used as inexplicable punishment. Fred Levinthal, his grandfather, was the family exception in having taken up the lowly rag (*schmata*) trade. Fred also liked spending his time going to Broadway shows, helping G.I.s get tickets, playing pinochle and gin rummy at the Lone Star Boat Club. Situated in a New York high-rise, this "sports" center had a swimming pool and other facilities which the membership ignored for cigars and card tables.

Fred had been driven from the marriage bed by his hectoring spouse, Rose (the champion golfer). He still resided in the apartment but relocated to a tiny office. David didn't know that his grandfather slept in this den-bedroom. The dark, cramped quarters didn't suit the old man's open lightness, his love of illusion and games of chance. But they harbored a secret life. Fred kept piles of *Police Gazette*s there. When David visited Fred, he poured over the forbidden pages with their sensationalized true-life stories, staring at photographed criminals, trying to penetrate glances masked by protective black rectangles.[19]

His fabricated rooms contained this childhood memory of forced exile, vague contingencies, mistaken identities, faceless perpetrators, police blotters, detective stories, sordid popular fiction. As he worked, one thing led to another. He had no way of planning it. Obscure, twisted tales of modern life might unfold in the constructions at any time. The thought was so delicious it gave him goose bumps.

He didn't care to define it to himself any further than by proceeding with the conviction that although he considered himself a fearful person, with internal scars to prove it, at his work table he was calm, orderly, completely secure, able to conjure effects of unnameable intimacy that he'd been incapable of producing any other way. It also occurred to him that these were intimacies he longed to experience in real life but felt, at the time, were not only dangerous but quite beyond him.[20]

He poured light over his little street corners, dotted it at roadblocks, flowed it through tiny restaurant windows onto sidewalks. He backlighted porch railings and garden-apartment staircases. With the right illumination, the seclusion of a late-night diner became a lure for ousted pub crawlers, seeking the next Station of the Cross.

Yellow or red acetate over the pin lights blasted streets and offices with infernal heat. Blue in movie theaters, subways, parking garages, train-station waiting rooms, and hotel cubicles was deliberately "thin"[21] to conjure a world of depleted, dying-on-the-vine, door-to-door salesmen, third-rate con men, "bald-headed men who comb their side hair across the top,"[22] lost souls waiting for the next deal.

His lighting didn't imitate the sun or moon. It abstracted the space, heightening the aura of being lost. He liked neon bleeding from pulsating advertising signs and theater marquees onto shiny pavements.

Los Angeles . . . smelled stale and old like a living room that had been closed too long. But the colored lights fooled you. The lights were wonderful. There ought to be a monument to the man who invented neon lights. Fifteen stories high, solid marble. There's a boy who really made something out of nothing.[23]

 Neon was heroic. Like spilled paint, its reverberating hues linked situations logically disconnected. Night light in the city exposed hidden corners—the entrance to a motel, seen from the street, striptease artists in their dressing room. It transformed the office of a lone employee, absorbed in an after-hours phone conversation, into a lurid hellhole. Eerie, nuanced, bold, tragic, the light "made something out of nothing." As anything he wanted it to be, it seemed entirely new.

 But nothing he was doing was new to him. The spatial emanations were figments of a lifetime of dreaming. From the beginning, as with his grandfather's room, this had to do with the way physical enclosures harbored the hidden.

D

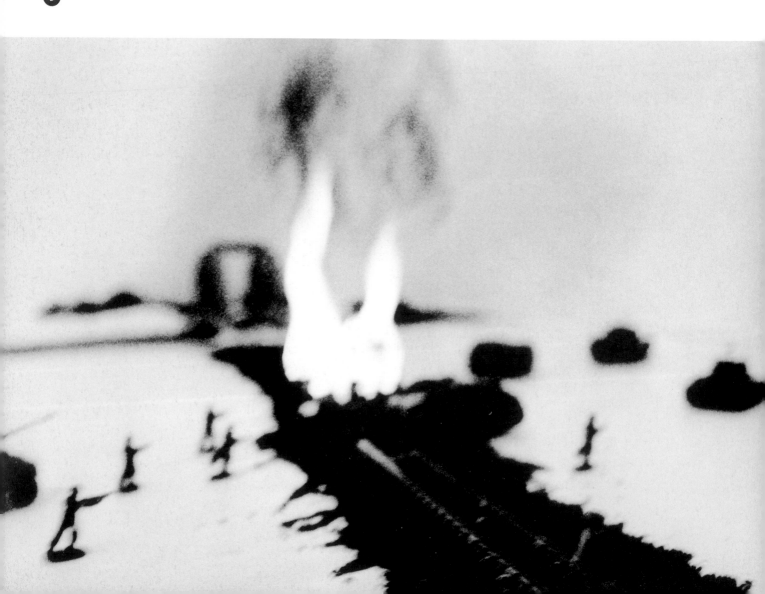

4.

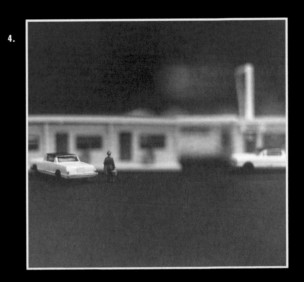

5.

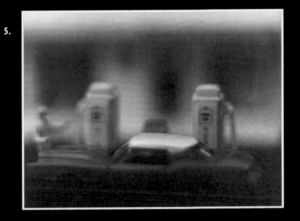

AN EROS OF PROPERTY

Closed spaces also had the power to initiate action. At six or seven, living with his family in an airy California dwelling, he was disappointed that his own room had no window to the outdoors. After pacing the length of the house, outside, to determine where his own room would be, he took a hand drill belonging to his father and began making a hole in the wall to produce the window he lacked. He didn't get very far. His father was astounded that this eldest child, designated role model for the other siblings, was not only prepared to ruin his drill by boring into cement, but had no qualms about assaulting the family sanctuary. He punished the boy—"No T.V. for a week!"—and put him in his room. After a few hours, the little prisoner managed to climb onto a high narrow ledge where a glass panel allowed him see into the living room. Forgetting his confinement, he sat on the ledge, eating Halloween candy, engrossed by the pattern of moving figures on the television screen.[24]

The stupefying, yet wildly generative power of television and movies for this artist is a matter of great importance, to which we shall return. Let us examine the first part of the account: a little boy, completely comfortable with an ability to transform his physical environment by any means necessary.

Walls were alive, the sounds they concealed, visual. At Yale, a former love was betraying him with his best friend: "By myself, I hear. Jane's voice in the room next door. I see and hear."[25] The enclosures were only temporary impediments. As a child, he used a drill to try and change them. As an adult, making cardboard constructions, he conjured allusions to personal pain. From detective fiction he recalled stories full of cheap real estate, from which modern romance flowed.

He was, and still is, addicted to the violent, spiritual darkness of Mickey Spillane, Dashiell Hammett, Jim Thompson, James M. Cain. He ponders the soliloquies of Raymond Chandler's detective, Philip Marlowe, who solved crimes amidst the glow of neon and the stench of "gin and bad air."[26] If walls were erotic, property was more so. Cain's real estate developer, Graham Kirby, and his child bride in *Cloud Nine* fueled throbbing sex with perpetual visions of remodelling:

When she was lying close in my arms, . . . I lined it out: "The whole farm, . . . sixty seven acres, I mean to chop into one-acre lots, big places, estates, and write it into the deed that I approve exterior plans. It's how you do, in . . . all places that really have class. And I'll approve nothing but Southern mansions, with oaks, elms, gum, and magnolias. And that house that Jane Sibert lives in, I'll . . . make it the most Southern mansion of all. I'll peel off that front porch, put a neat little entrance in, and an annex right and left, a rec room and a garage, and—lo and behold—it's Southern something to look at. And that mud-hole she calls a drive, . . . what am I doing with that? I'm dozing the mud out first, then lining it with bricks—putting brick borders down, inside and outside the loop, and painting them with whitewash. Then, between the two rows of brick I'm filling with oyster shells. . . . [T]hey're prettier. They're snow white, and they look like Dixie!"[27]

8

Property as foreplay: all structures, inside and out, promised sexual adventure. Any site, from an empty house to a car parked along a tree-lined highway at night could be erotic. His sister's pulp-fiction comic books–*Love Diary*, *My Love*, *Young Romance*–reinforced imagined intrigues. "Learn: The Art of Kissing," subject of a teen "advice" column, cautioned:

If you make a date with a guy you don't fully trust–maybe somebody who has a "reputation" with girls, or somebody older–don't go out alone with him until you do trust him. Don't park in a lonely place or stay with him in an empty house. That way you'll feel more relaxed, and relaxed people kiss better.[28]

The banal, twisted counsel inflamed him.

Detective fiction, rife with the same feelings, cast spells of bottomless pits. Characters, resembling his buried, inner self, were directed through darkness by forces beyond their control. In *The Big Heat*, William McGivern, telling of urban corruption brought to its knees, slowed the pace of the story with a series of melancholy spaces. Surveying a city from distant vantage points produced states of meditation that led the hero to fierce resolve.

Bannion walked to his hotel. There was a fine rain falling now, and the winter darkness was closing in on the city. Neon signs flashed above store fronts, and automobile headlights bored yellow tunnels into the gray, wet gloom. He picked up his key at the desk and went up to his room. He poured himself a drink and sat down at the window without bothering to remove his hat or coat.

He stared at the city. Now it's time to start, he thought. It was a satisfying realization, it gave a purpose and outlet to the storm inside him.[29]

To supplement the cardboard scenes, he bought ready-made buildings, mock motels, and storefronts from hobby shops, or those offered in catalogues published by suppliers of settings for miniature railways. Such sources promise the world, from "Instant Horizons" or "Mini-scenes," with "bums" taking cat naps in a run-down shanty, to grim conclaves of mourners celebrating a funeral, complete with rows of cemetery graves.[30]

His own theatricals would never convince the curious that they'd landed miraculously in what the catalogues called "Smalltown USA."[31] He was a nighthawk solitary, a painstaking builder, consumed by urban shades that mirrored his own. He found he could suggest through parking garages, sidewalks along a picket fence, or junkyards near a desert highway something urgent and alien, darker than mere night.

I drove on past the gaudy neons and the false fronts behind them, the sleazy hamburger joints that look like palaces under the colors, the circular drive-ins as gay as circuses with the chipper hard-eyed carhops, the brilliant counters, and the sweaty greasy kitchens that would have poisoned a toad.[32]

The descriptions were not only authentic, their humor intensified the realism. From memory, he began listing such places. Long and detailed, the compilations were so overwhelming they frightened him. It was like forecasting dreams he hadn't yet had. Or had he? Actually, unless he worked, he couldn't articulate them. But he knew instantly when he had what he wanted. Cutting a rectangle from a cardboard wall to make a window, he shot light through it from a concealed source and created not a place as much as a frame of mind. Something unspeakable might transpire here.

I lingered for some moments on the landing. The whole building was as quiet as the grave, a dank, dark smell rising from the well hole of the stairs. I could hear nothing but the blood throbbing in my ears, and for a while I stood still, listening to it. Then the dog began to moan in old Salamano's room, and through the sleep-bound house the little plaintive sound rose slowly, like a flower growing out of the silence and the darkness.[33]

Camus understood. An ordinary apartment house could contain unseen tortures. Hearing his old love on the other side of a wall, David had been subjected to the same involuntary voyeurism. No need to show it. Suggestion was everything.[34]

E

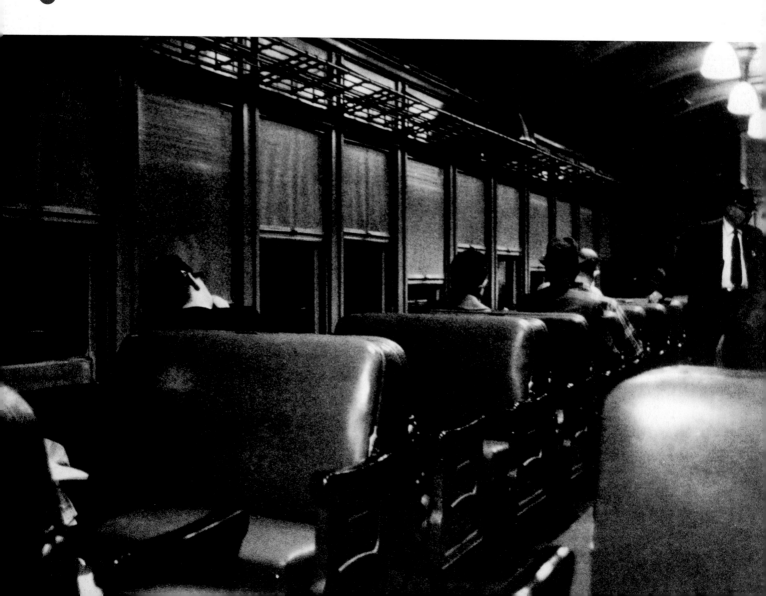

6.

9.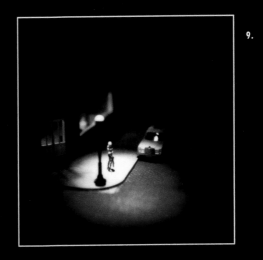

7.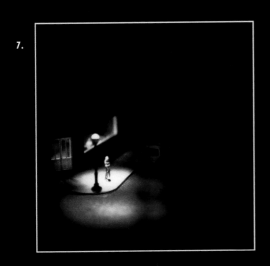

10.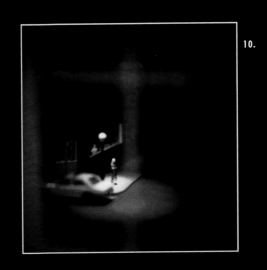

8.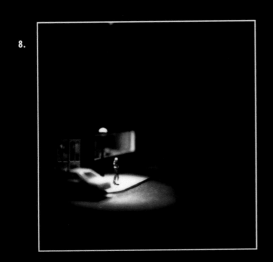

11.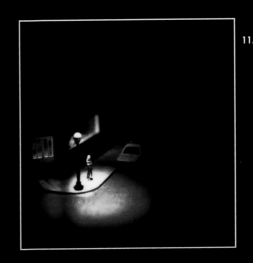

11

Placing two dollhouse-sized billiard tables in a room and glancing light over them, he approached what he was after. He entered the enclosure. Abducted from real life by his house of games, he breathed heavily and like a dreaming philosopher, crossed the frontier, plunging into his fabrication.

A decade before, in the seventies, he'd noticed two identical colonial-style dollhouses in a Palo Alto toy store. Forgotten stock, they were covered with dust, which only enhanced their attractiveness. Besides, they weren't ordinary dollhouses. One could see into them in the usual way, but they had a peculiar feature in consisting entirely of clear plastic. The inhabitants of the rooms could be spied upon from all the others, through walls, floors, ceilings. Absolute voyeurism. Absolute surveillance.[35]

In one house the dolls included some campus cuties, a black chef, and a Liberace-like figure playing the piano. He paid seven dollars for this dwelling. "The dollhouse's aptest analogy is the locket or the secret recesses of the heart: center within center, within within within," Susan Stewart has written.[36] Later, he returned to the store and bought the other one.

EVERYTHING IS WELCOME

"Each new object, well considered, opens a new organ within us," wrote Gaston Bachelard, prime specialist in such matters.[37] The phenomenon is as old as reveries that produce poetry. As Bachelard explained:

[He] who gives himself enough solitude to enter the region of shadows bathes in an atmosphere without obstacles where no being says no. He lives by his reverie in a world homogenous with his being, with his demi-being. [He] is always in space which has volume. Truly inhabiting the whole volume of his space, the man of reverie is from anywhere in his world, in an inside which has no outside. . . . The world no longer poses any opposition to him. The I no longer opposes itself to the world. In reverie there is no more non-I. In reverie, the no no longer has any function: everything is welcome.[38]

He had lamps, but he needed other furnishings:

It was a wall-bed living room, with the wall bed down and rumpled. There was an overstuffed chair with a hole burnt in the arm. A high oak desk with tilted doors like old-fashioned cellar doors stood against the wall by the front window. Near this there was studio couch and on the studio couch . . .[39]

He bought tiny beach umbrellas, park benches, chairs, couches, dining-room sets.

A miniature brass bed, placed in a hotel space and lighted, suggested the invasion of a fatal presence. Light animated the knobs of the bed, which he arranged to look as if someone had

just departed, as if their warmth were still on the sheets: "Bannion slammed the door on her and then stood with his back to it and stared bitterly down at the small, soft indentation her body had made in his bed."[40]

His own sensitivity to place, reinforced by dollhouses, detective stories, "graphic novels," love comics, he also found in certain guidebooks for photographic amateurs. *How to Take and Sell Erotic Photographs: Secrets of the Masters*, by Victor Wild–the name, itself, is exultant–summoned readers to fight attitudes of Victorian prudishness and "express the demand for sexual freedom which is vital to our health and well-being."[41] David was a serious reader, an intellectual snob. Briefly, at Stanford, he studied ancient Greek. But researching modern romance, he had no prejudices. He didn't care where his ideas came from.

Simple props can give your story meaning. A transparent cloth or garment can create the exciting effect of seeing something that was not intended to be seen. A rumpled sheet can give the feeling of sexual promise.[42]

Engrossed in a philosophy of deep play, he made the unintended visible. Energized by tabletop trial and error, he was amazed by his attention to detail and the need to get things right. If a scene required a police car, he painted an ordinary toy car black and white to convey the effect.

Manipulating the small in deliberately contracted spaces, he felt himself expand. Controlling memory and time, strangely, he became a tourist in atmospheres that suggested his own inner life and, more mysteriously, its elusive prehistory.

Such dreams unsettle our daydreaming and we reach a point where we begin to doubt that we ever lived where we lived. Our past is situated elsewhere, and both time and place are impregnated with a sense of unreality. It is as though we sojourned in a limbo of being.[43]

BODIES WITHIN BODIES

He needed players, to fit comfortably into the scale of the tiny space-object schemata, to animate the dreams. Reading a novel by Josephine Humphreys, he was enthralled by the strength of its interior voice:

When she steps into the hall, something catches her eye. A naked leg. On the floor just beyond the children's door a tiny pink doll's leg tapering to a pointed foot, a tiny high-heeled sparkly shoe. She stands in the hall looking at it, like a passerby happening upon evidence of a crime. The sun hits the shoe at the right slant to throw glints into the air. She can't see what else is behind the door, but she can guess. It will have to wait. She pulls the door shut without looking farther and tries to forget the leg.[44]

12.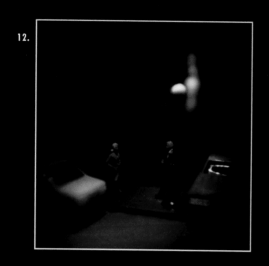

15.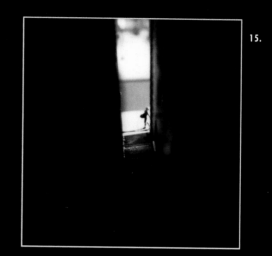

13.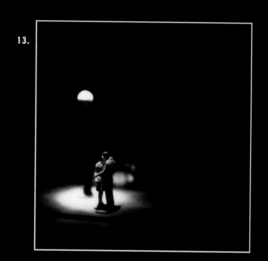

16.

14.

17.

Doll parts, spied upon, stopped being toys to become troubling versions of memory.

He chose miniature personages, less than an inch tall and perfectly articulated (fig. A). He poured over vast offerings of these diminutives in the model railroad catalogues. The most vivid ones, "intended for modelers . . . not recommended for children under 14 years" because they had "pointed extremities," were made by Preiser, in Germany.[45] Plastic and "carefully hand-painted," many Preiser figurines, connected with railroads, feature signal-box workers, track-maintenance gangs, delivery men with loads.

Preiser's figures also emulate every imaginable modern, human gesture. Collected, mostly in groups of six, housewives spill buckets of plastic water, beat carpets, sweep; on their knees, they scrub floors. There are wedding parties (choice of Catholic or Protestant), film and television crews, hospital emergency teams, groups of photographers, passersby, dancing couples, shoppers, teenagers, moped riders, figure skaters, every posture of the modern commuter, chefs, wedding guests, graffiti sprayers. For crowds, a single package contains twenty-six "passersby, standing and walking." At a "bargain price," one could acquire a tiny mob of 190 people.[46]

F

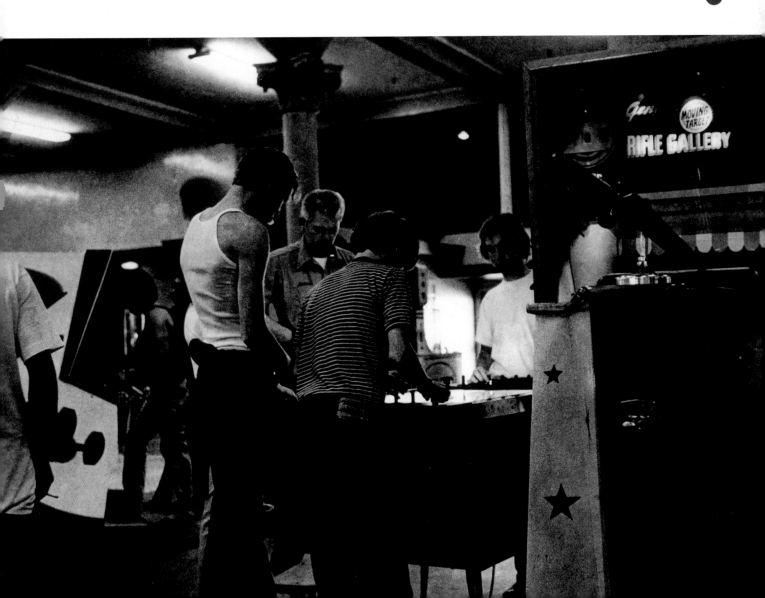

The banality and abundance of the figures in the catalogues is staggering. "To keep company with objects, there must not be too many,"[47] Bachelard observed. Selecting carefully, the fantasizing builder directed them to do what he wanted. It wasn't easy. Testing the water in 1982, he photographed, in black and white, a toy-furnished street scene with lamppost, mailbox, parked cars, and a male "commuter," seen from behind (fig. B). Isolating the figure gave the vignette its charm, but it remained a street scene of toys.

The shadow plays of *Modern Romance* had to transcend their component parts. He ignored Preiser's designated categories for the figures and made them conform to his own situations: a nude sunbather looked perfect, under his lighting, as a woman reclining longingly on a hotel-room bed. Recalling a day at the beach with a real sunbather, he wrote:

. . . lying in the sun. Yes she is truly beautiful, soft-white skin, gentle breast, small stomach, lithe legs, unshaved arms, yet an almost hairless body. Her breasts are larger than I had thought. Lying back, watching her turn to the left, seeing her back, thinking how lovely it would be to hold her. Her soft shoulders. The day ended with another kiss. I can't tell what it means. There is the ecstasy of her kiss, yet it is light, soft. As the evening drifts on I wonder if she feels it is an obligation?[48]

Every figure arrangement would contain similar puzzlements of modern romance. He made two Preiser "passersby" enter a motel. A detective writer might turn one figure's private musings into a fated future:

Carrying your own bag in a motel is a feature I can't get used to, . . . I picked up our two and followed her upstairs. She found our suite and unlocked it, and I took our bags in. She followed and closed the door. I was up tight with the moment I'd dreaded, being alone with her, due to spend the night, and perhaps the rest of my life.[49]

But the builder wasn't illustrating. As in his journal, he was remembering, agonizing, conjuring from within. Victor Wild suggested, "A nude figure in an old building or car can suggest abandonment or vulnerability. This has a powerful appeal to the sado-masochistic latencies of the viewer."[50] The fabricator wrote in his sketchbook:

Try using men with hats in empty rooms. . . . Dead man, drunk on sidewalk. . . . Woman on edge of bed. . . . Back of man facing half-dressed woman. . . . Man at table back to bar. . . . Woman putting on bra in front of window. . . . Show legs only of woman walking on the street. . . . Woman in chair at end of bed sitting by window, feet on either bed or radiator. . . . Man kneeling over nude woman.

The sequence implies a tale, primal, even cruel.[51] In erotic tableaux with more than one figure, another Preiser "commuter" with a suitcase became an evasive lover slipping from the grasp of a woman in a hotel room. Or is he forcing himself upon her? Another couple parts abruptly on a subway staircase.

Passengers for a Preiser railway setting became people finding seats in a darkened theater:

Bannion followed him . . . into the lobby of the burlesque house. He showed his badge to the ticket-taker, and went into the dark. . . . It was not a pleasant place; the carpets were worn and dusty, and the acrid tang of a urinal disinfectant seeped under the smell of stale tobacco and perspiration. The audience was a small one, fifty or sixty men crowded down in the first half dozen rows, but they were having a good time, laughing gustily at the pair of comics and the big half-naked blonde on the stage.[52]

McGivern's sordid theater gradually expanded into laughter, actors, and the juicy, spot-lit body of a dancer. Similarly, David's constructed, furnished, and illuminated spaces became more than their cardboard and plastic. Through the dramas that their joinings implied, so did the little people; the tiny became enormous.[53]

The discrepancy is essential to understanding how this artist thinks. As a bright child who skipped a grade in school, among his classmates he would always be "the smallest and the youngest, always out of step. No one should have to suffer that." But the experience was indelible. By adulthood the artist declared comfortably, "With the small, I'm the most me."[54]

A PHILOSOPHY OF PLAY

Ever the strategist, David Levinthal risks seeming idiotic, throwing off those who seek to understand him. He likes declaring, with innocent aplomb, how much "fun" it is to make art with toys.[55] Some apologists play along, naively taking him at his word.[56] Others seek to give his method the currently acceptable artistic cachet by grouping it with that of practitioners of goofy, postmodernist theatrics. Peter Schjeldahl describes Levinthal's style by saying that he "belongs to a 1970s generation-post-Vietnam cohort of disaffected ironists ranging upward in refinement from David Letterman to Cindy Sherman," whose attitude is "marked by ferocious skepticism." Like the others, Levinthal's "basic hip . . . move" is "to master a medium in order to insult it, while . . . glorying in its . . . ultimate, spectacular emptiness."[57]

Such categorizing not only misleads; blindly, it robs the artist of his actual intentions. Garry Trudeau, who knows him well, observed differently.

17

To hear David Levinthal talk about his art is to sometimes come away with the impression that he couldn't possibly be up to anything consequential. He smiles too much. He's too self-effacing, too slow to rationalize any ambiguities in his work. He actually respects his audience, believing them capable of processing powerful, provocative images on their own. This child-artist with his toys expects the rest of us to act like grown-ups.[58]

Many don't. Critic David Corey ignored the artist's work to concentrate on his own childhood recollections. Schjeldahl stormed out of the sandbox: "He now takes himself too seriously for me to want to take him in any way."[59]

Finding supreme comfort in a near-maniacal search to possess all kinds of small things from the world of children,[60] David Levinthal discovered in manipulating these things the necessary arenas for addressing an open city of artistic possibility. The domain is not theoretical. As Bachelard explained, it is poetic. Over a century ago, French poet and critic Charles Baudelaire recognized in the "barbaric simplicity" of toys the enormous force of their approximation to the real. Toys were a "child's earliest initiation to art, . . . the first concrete example of art," so indelible that the experience of fine art in adulthood would never produce "the same feelings of warmth, nor the same enthusiasms, nor the same sense of conviction."[61] David Levinthal is Baudelaire's exemplary artist-child.

G

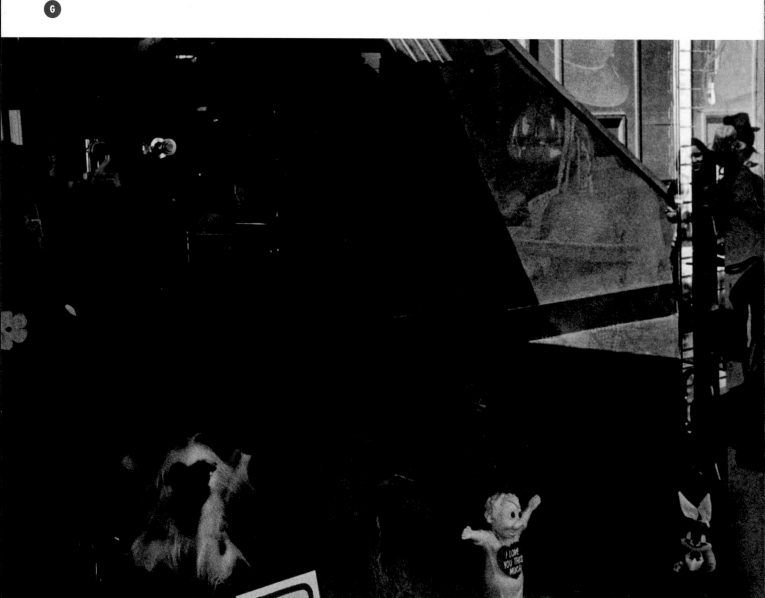

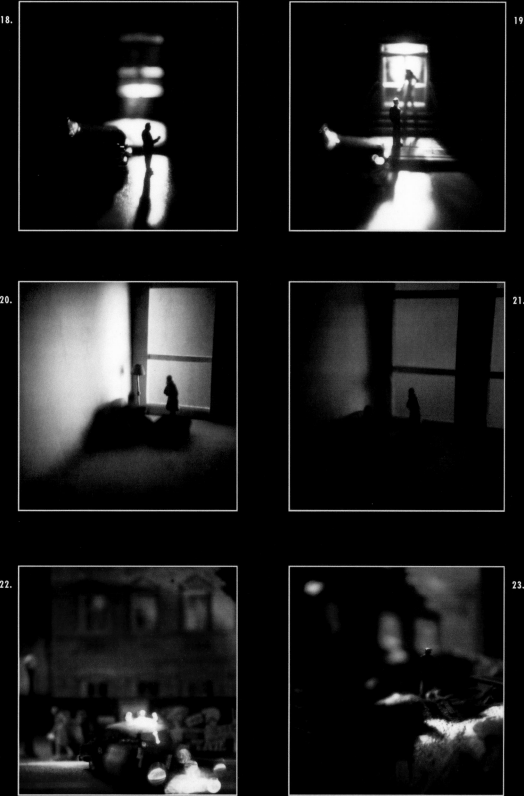

18.

19.

20.

21.

22.

23.

He was a well-trained viewer, exposed from childhood to fine art, which he associated with the pleasures of solitude. At age thirteen, in Paris, he made sure to arrive at the Louvre early enough to be among the first to enter. He ran to the great hall where Jacques-Louis David's *Sacre* (Coronation of Napoleon) hung, to be "in that room all by myself"[62] with the emperor, who, about to crown his consort, Josephine, raises his arms as if to place the crown on his own head. Much later, in Rome, David was so excited by Caravaggio's paintings that he returned repeatedly to the dim churches with pockets of coins. Placed in the requisite slot, they flashed on spotlights to reveal *The Conversion of Saint Matthew* or that of Saint Paul in tableaux-vivants of near-life-sized actors emerging from deep shadows.[63] He was the perfect recipient of such illusory theatricality. But to originate his own theaters, he had to begin elsewhere.

Escape into solitary play for this artist is inextricable from his family role. As the oldest sibling, he was more—"the good son" in a family of high achievers, regarded by his mother as a kind of sage, her other children's "third parent."[64] Loathing high school, he performed well, did what was pleasing, hid his true responses to a high-strung father's explosive outbursts contrasted with a mother's consistently cool reserve.[65] He kept the peace, assumed a cheerful veneer of clarity and purpose, and became ill: "I seem to be, / what I'm not, you see," sing The Platters. He, too, was "The Great Pretender."

Always gathering more toys than he needed (the second plastic dollhouse, a third metal one—countless others), using them as the basis of everything, un-sage[66] had nothing to do with expectations. Entering the realm of creative uncertainty, from the vague shadows of his imagination, he began to invent. It may perplex those who try and understand the surprises that we count on artists to give us, for many art writers respond to results alone, being ignorant of or uninterested in the beautiful mess from which art originates. In the mess of play, David discovered something he'd never been taught, the intelligence of rapture, the sacredness of enthusiasm.[67]

Because little figures are the bedrock of his work, their various assignments have been recounted endlessly.[68] It is well known that from age eleven through high school he sustained battles with toy soldiers for days on end. He was faithful to his tiny comrades longer than anyone would have deemed appropriate. As a college freshman he filled two rooms in the family house with the figures and played with them during vacations behind locked doors: "And the children who play at war! . . . I mean the solitary child who controls and leads into battle two armies all by himself. . . . there will be dead bodies, peace-treaties, hostages, prisoners, tributes to pay."[69] It was a need.

In his twenties, nostalgia for this sort of solitary aggression was so strong that after buying a new box of the little fighters he made a photographic record of each step of unwrapping the package containing them (fig. C). The "Combat Series" sequence is a dialogue of hiding and display, from an initial view of the mysterious object, concealed under paper and string, which beckons with an almost sexual promise of access, to its gradual disrobing. Devotional objects, gradually revealed, were versions of voyeurism implicit in the plastic dollhouses that he'd purchased shortly

before. After the package is unwrapped, the soldiers are seen arranged in military engagements which erupt in the images like scattershot.

Photographing the war games to accompany a serious historical text in his and Trudeau's *Hitler Moves East* was an imaginative leap (fig. D). The chaotic skirmishes take place among actual fires that David set to simulate warfare. The spaces don't describe. They are vaporous nowheres, expansive and spectral.[70] Child's play was not only relevant to recounting real war games.[71] It gave the photographer's love of history, combined with his consuming hobby, compelling psychological authority.

Every philosophy of play insists on the fact of this authority, whether the player be child or adult. Where artists are concerned, Baudelaire's "Philosophy of Toys" explored play through a romantic theory of artistic creativity by linking it to the "spirituality of childhood." Later, the poet elucidated this more completely in "The Painter of Modern Life," calling genius "nothing more or less than *childhood recovered* at will."[72]

Child's play is automatically an abstracting process. Engaging with toys, Baudelaire observed, children enact a "great drama of life, reduced in size by the *camera obscura* of their little brains."[73] Furnished, lighted, and populated, David Levinthal's tabletop settings, versions of the dark rooms of his own brain, would be subjected to greater abstraction by a process that he'd determined from the beginning. He photographed them, but not as he'd photographed anything before.

CAMERA OBSCURA

David Levinthal took up the camera at age seventeen, in 1966, borrowing his father's Nikon to take a course at Stanford's Free University. The curriculum included sixties California-style courses like "LSD and Tantric Yoga." But he wanted simply to shoot, develop film, and print negatives. The only undergraduate in the course, he saw his teacher, filmmaker Dwight Johnson, as a god: "Dwight was cool. I wanted to be cool."[74]

It was a period, generally, of cultural disorientation. Thinking himself immune, he soon encountered his own version. After driving to the beach to take a picture of sunrise over the ocean, he was shocked to realize that on the West Coast at that hour he would find no such thing. Perplexed and alone in the pale light, staring in the wrong direction for the red orb that never appeared, he looked down and made a picture of wet sand. Everyone thought it was moonlight.[75] The event was auspicious, an epiphany: finally, pure photographic verification would never be very interesting to him.

Yet, in the early seventies, like many young photographers, he pursued the documentary style of the great masters of the street, Lee Friedlander or Bruce Davidson. Even then, he had a feeling for interior geometry. In 1970-1971, shooting a Palo Alto railway car as if he were a passenger,

he filled the frame with a rushing perspective, letting the overhead lamps read white, giving the plastic seatcovers a warm glow as commuters slept or read, and a conductor moved down the aisle (fig. E). The image, prosaically clear, perfectly imitates all he admired. The closed space and isolated figures also are the vehicles of expression to which later he would turn to conjure, in miniature, other notions of lonely obscurity.

The geometry became bolder and fractious in a view of pinball machine players in Santa Cruz from the same period (fig. F). As men and boys concentrate on winning, their body language is another version of the architecture of the sealed-off room, with its ceiling patterns articulated by fluorescent lighting, lights from a "Moving Target Rifle Gallery," and other machines. The image clearly records a place. It also conveys a primal concern: male absorption in the game palace.

This documentary mode, originated by Atget and promoted from the 1960s by Friedlander, thrived on surrealistic insights through optical confusion. David's Santa Cruz storefront, seen obliquely, is a black hole, animated by tiny non sequiturs: bunny rabbit; smiling baby doll wearing a big heart; Barbie-type doll wrapped in tulle; rows of lights from nowhere; and two real bystanders, who, as in Atget's famous views of Paris shopwindows and storefronts, by stopping to study the photographer, inevitably join his dream (fig. G).

H

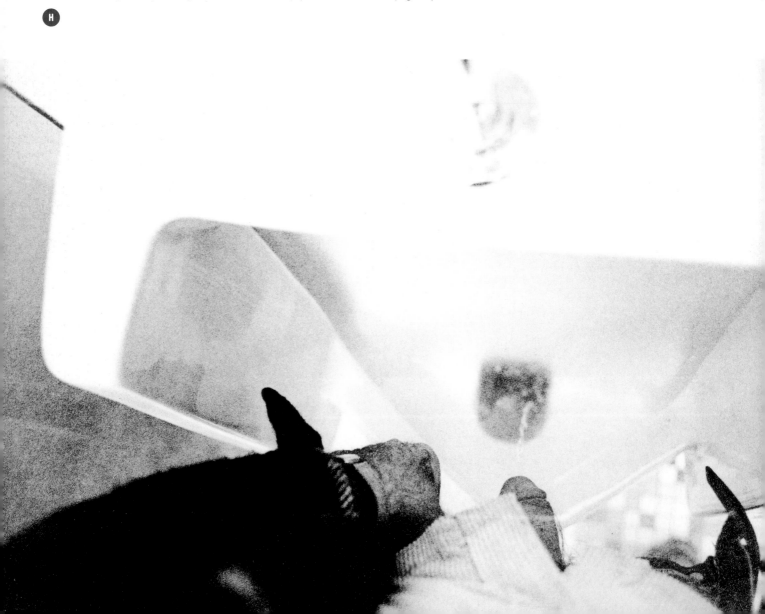

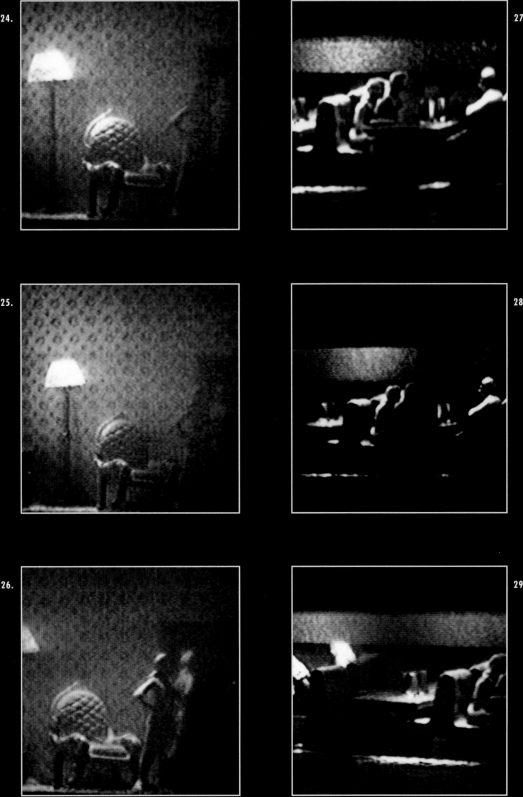

24.

25.

26.

27

28

29

In 1971, having enrolled in graduate school at Yale's Department of Design to study photography formally, he was assigned to do a nude. He set it in a bathroom which was not only a haven for him but also a place of personal degradation, where he stored cortisone enemas, scanned toilet water for evidence of blood. He stood at a urinal, trousers unzipped. Looking down, he achieved a painful self-exposure, the only kind of nudity at the time that meant anything to him (fig. H).[76] It was another idea, recalling the mad poet, John Wieners, who, when asked if he had a theory of poetry, responded, "I try to write the most embarrassing thing I can think of."[77]

At Yale he courted further embarrassment by shooting close-up portraits, not of friends, but of individual donuts, Chuckles candy, and M & M's. He was recording American pop.[78] Even so, no one could figure out what he meant. Herbert Matter, who taught him lighting and studio setups, liked the work. David also started photographing the toy-soldier skirmishes that became *Hitler Moves East*. Walker Evans wrote: "This person has a really unique and interesting vision."[79]

PHOTOGRAPHING THE THEATER

The vision that finally became the photographs of *Modern Romance* was consistent with what he'd already tried by continuing to visualize American history and popular culture. But there was a difference. Creating the setups, complicated by reflecting mirrors, designing the lighting, and arranging the figures, was an extended process that introduced him forcibly to forgotten corners in himself. "I heard . . . that you write ROMANCE stories!" a beautiful, hopeful blonde swoons. "Just between us," responds the dark, square-jawed hero, "I'd rather LIVE them than write 'em!"[80] Photographing, he lived them. But he did not simply record what he had built. He completed the theaters by altering them profoundly. Before *Modern Romance* his vision may have been "really unique . . . interesting." After the series, it would cease to be merely "interesting." It would flow more freely, becoming, consciously, darker.

He began by making black-and-white images of certain sets with a Rollei-SL66 single-lens camera. Bedroom scenes, with and without figures, emulate the shadow artistry of film noir. Light enters on tiptoe, grazing a brass bed where a dusky pile suggests someone sleeping (figs. 1, 2). Hot, white light in an open doorway is a threatening invader. "Do me a favor, will you? Keep away from the windows. Somebody might blow you a kiss" (fig. 3).[81] Reproducing a motel and gas-station pumps in blurred chiaroscuro atmospheres recalled the smokey war theaters of *Hitler Moves East* (figs. 4, 5). It was exactly what he wanted.

The pictures had to enhance arrangements full of lurid color. Polaroid chemistries, which enhance reds and yellows, were perfect for the nocturnal lighting he'd created. Besides, the SX-70 system ejected from the camera little pictures, each of which was unique. In the early eighties, SX-70, for many, was still something of a hobbyist's instrument. That he used a virtual toy to reproduce

his dramas felt completely natural.

He liked the scale of the images. Since from their inception, the little theaters of *Modern Romance* were silently dedicated to certain young women whom he'd allowed to torment him, it was appropriate that the renditions of them be pocket-sized and portable, like cherished wallet photos or magic talismans. They also had to embody intimacy. Using a close-up lens attachment, "my most cherished possession," he placed the camera so near the scenes that the expelled image knocked over the figures.[82]

Among the documentary-style photographs done earlier in New Haven, one shows a diner with a dwarf employee whose shoulders barely reach the level of the countertop (fig. I). Shooting toy personages with SX-70, he proposed tininess as terror, memory dissolved of "all its clear relations." From a high vantage point, the voyeur spotted a lone woman under a street lamp. She seems marooned. It's past midnight. Darkness will gobble her up if the pavement's blood-red sea doesn't drown her. We scan the scene. Minute, she's there. We sense she shouldn't be. We can't take our eyes off her, fearing that if she isn't held safely in our gaze, something awful will consume her.

> *The street-lamp sputtered,*
> *The street-lamp muttered,*
> *The street-lamp said, "Regard that woman*
> *Who hesitates toward you in the light of the door*
> *Which opens on her with a grin.*
> *You see the border of her dress*
> *Is torn and stained with sand,*
> *And you see the corner of her eye*
> *Twists like a crooked pin."*[83]

SX-70 gave immediate results. In a few minutes there was a clear picture. This enabled the photographer to shoot the same setup over and over, quickly studying effects of camera-angle changes or of elements he decided to move, subtract, or add. In the many variants of the lone-woman theme, some feel like film stills that a hidden observer might have made as a screen drama unfolded. Others feel as if the observer stood at his window, night after night, to follow a repeating pattern of events. The impression is not of Hitchcock's *Rear Window*, where everything small is concrete.

At times, David's lone woman is barely visible. Or the photographer altered the lighting and changed the position of a parked car. One, shot as if through a window, shows the blur of wooden molding (figs. 6, 7, 8, 9, 10, 11). Versions, shot from street level, have a man approaching the woman (fig. 12); or embracing her (fig. 13); or, simply, we are given the street, illuminated only by the diner from which she presumably emerged (fig. 14).

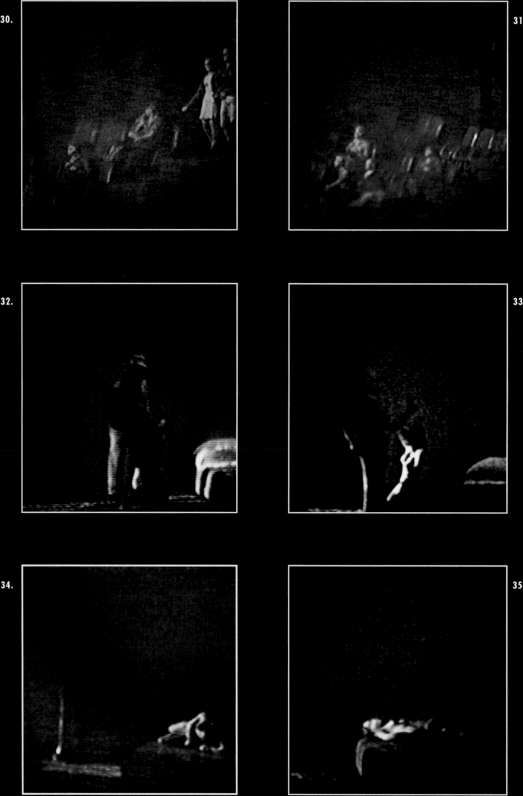

In these trials, the photographer is a cat, circling, scanning, exploring every point of view. Studying the previous pictures he achieves all possible inflections of what seemed static at the construction stage. With everything in potential flux, there is no single way to experience the scene. The woman appears again, smaller still, and more distant, alone in a shaft of light between two tall buildings, oblivious to eyes charting her every move (figs. 15, 16, 17).

In this world no one is safe. Even with couples or groups, the mood is threatening. A man waits in the street facing the lighted foyer of a building (fig. 18), or he waits for a woman about to descend some stairs to the street (fig. 19). Two women converse in a high-ceilinged space (figs. 20, 21). Ordinary. But shadows come and go, and a stalker is making a record of it.

Paranoia in miniature: David's pulp magazines advertised mail-order toys with secret voices: A "SPY RADIO hidden in a pen":

Listen in secret to your favorite sport, news or music show! Use almost anywhere—bed, school, in or out-of-doors. Tiny earphone included for private listening. Amazing circuit is self-powered. Plays forever at no cost! No batteries![84]

I

Like fountain-pen music, "whispering lunar incantations,"[85] the scenes are mysterious, suffocatingly close, wells of memory. Toy figures cease to be playthings. Each little being is so preoccupied with the incidents of his or her life, receiving signals, perhaps, through tiny earphones, that we are forced to believe in *their* own capacity for fantasy.

The issue is again poetic. Consider the work of Charles Simic, where miniature allows players their own games.

Fingers in an overcoat pocket. Fingers sticking out of a black leather glove. The nails chewed raw. One play is called "Thieves' Market," another "Night in a Dime Museum." The fingers when they strip are like bewitching nude bathers or the fake wooden limbs in a cripple factory. No one ever sees the play: you put your hand in somebody else's pocket on the street and feel the action.[86]

Similarly small and active, David's little people become denizens of our own darkness. As with the constructions, actual size is subsumed by the fact that we almost cease to experience them as viewed. In "somebody else's pocket," we "feel the action." They have entered us. We have entered them.[87]

As the figures come and go, no particular point of view is necessarily the right one. All display the same contingency. Despite the square, SX-70 format, which contains them in a reasoned tableau, David's framing is deliberately arbitrary. Each attempt, however vague and unresolved, is its own psychological success. A police car's revolving lights obliterate apartment buildings and pedestrians (fig. 22). In images suggesting the city at night, often, one cannot tell what is actually going on (fig. 23). All convey the feeling that "at any street corner the absurd may strike a man in the face."[88]

In *Modern Romance* David united miniaturization and unease. How small could he shoot a figure and still give its gesture legible pathos? How obscure could a scene be and still be registered in the gut as authentic? The image lexicon for this was film noir.

WAS IT MURDER, OR SOMETHING SERIOUS?: NOIR

From the late thirties through the fifties, film noir turned much detective and other popular fiction into movies with a peculiar cachet. As a subcategory of Hollywood's classic, technicolor mainstream, film noir's hallucinatory, "Hollyweird" atmospheres were deft confections of American, underworld-style fear. David, a devotee,[89] attributes the dark corners of dread in *Modern Romance* to film noir's structures of entrapment, where confused characters, handed bleak or terrifying choices, are overwhelmed by incomprehensible doom.

D.O.A., a favorite, "started everything":[90] Frank Bigelow, during a night on the town,

unknowingly drinks radioactive iridium, slipped to him by an unseen, psychotic assassin. Desperate, with only a few days to live, Bigelow is not only the victim of the crime—"I'm here to report a murder, my own"[91]—he becomes its avenging detective and finally, as the genre would have it, kisses tomorrow goodbye.

"The night has no future," Bachelard has written. In New Haven in 1971-1972, the photographer used black and white to evoke "the weight of badly led lives"[92] and noir's fatalism through nightscape. One image looks like an arrest, though we can't be sure: a police car, with its revolving lamp, is a white smear, as is part of a nearby building (fig. J). A "detective," barely discernable but for a fragment of tweed, confronts a faceless "suspect" in leather. Unmistakably sinister, the scene casts a spiritual pall: "Someday fate or some mysterious force can put the finger on me or you for no reason at all," Al Roberts shudders in *Detour*.[93] The other image frames an empty highway. In this lonely place, everything is opaque black but for diminishing dots of street lamps, a headlighted fragment of brush, and white highway marks. A small pile—rags? an animal?—suggests panic's aftermath. Abruptly, something came "to the end of the line" (fig. K).[94]

The visual/psychological simplification is a noir staple. It is also a feature of crime comics. When the authors of *Kelly Green* convey the moment before the tragic murder of Kelly's husband in a drug bust, they rely on a completely black field. The soon-to-be victim is a small, silhouetted target, innocent, wary, about to enter a building containing the only object that counts—the gleaming muzzle of a shotgun (fig. L).[95]

But in film noir, losing one's life is nothing compared to the horror of living—recall Frank Bigelow. And there's Bradford Galt in *The Dark Corner* (1946): "I feel all dead inside. I'm backed up in a dark corner, and I don't know who's hitting me."[96] Building and photographing *Modern Romance*, David found, in streets and alleys, no-exit corridors, tunnels, elevators, phone booths, the same visual patterns of preordained misery.

"Do you want to talk business, or do you want to play house?" Robert Mitchum sneers in *Out of the Past*.[97] Streets seem deliberately to emulate toy models. Ceilings and interior corners have the pasteup look of dollhouses. In *The Killing*, the camera, mounted on a dolly, laterally tracks the rooms of a railroad apartment as though along plastic walls, giving them our own eyes: "I gotta live my life a certain way. Can't stand it when the walls start closing in."

Light rakes a thug's pockmarked face, satin pillows, sequined gowns, crystal decanters, silk cord, moonlit seascapes, and ubiquitous brass beds with equal fury. Flashing on rainy cities, seen from above, pools of lamplight are more animated than certain characters: "He hasn't got enough blood in him to keep a chicken alive."[98] A bare electric bulb or a match, lit in an empty cabin, explodes the emptiness. Cracking a transom it is the only clue that we're in a hallway. Light, agitated in dots or streaks, scores the wallpaper patterns of a sordid hole with agitated movement. Add to this the smoke of countless cigars and cigarettes filling the big screen: "If you want fresh air, don't look for it in this town."[99]

Pouting blondes, plagued gumshoes, and petty criminals in a "quest for the great Whatsit"[100] reduce to ghosts, selectively highlighted or incised along their contours with white lines. Switched on suddenly, desk lamps footlight the actors, updating Caravaggio's holier protagonists. Only in this *demi-monde*, where no one looks ordinary, would a character say, "One thing you gotta learn, kid. You gotta look and act like other people."[101]

Among the archetypes, the most consuming for David were the fatal beauties. "All women are wonders because they reduce all men to the obvious," Ken Niles says in *Out of the Past*. Never quite believable, they *seem* honest: "She had a face like a Sunday School picnic." Platinum blondes go kittenish: "You shouldn't kiss a girl when you're wearing a gun," murmurs Claire Trevor. "It leaves a bruise."[102] "Heaters" are men's business: "A dame with a rod is like a guy with a knitting needle."[103] One after another, the speech declares male helplessness against unfathomable female deception: "She's a weasel, that daughter of mine."[104] And Robert Mitchum explodes at the corrupt Jane Greer: "You're like a leaf the wind blows from one gutter to another." Later in the film, Virginia Huston tries a conciliatory tone: "She can't be all that bad, no one can." Slams Mitchum, "But she comes the closest!"[105]

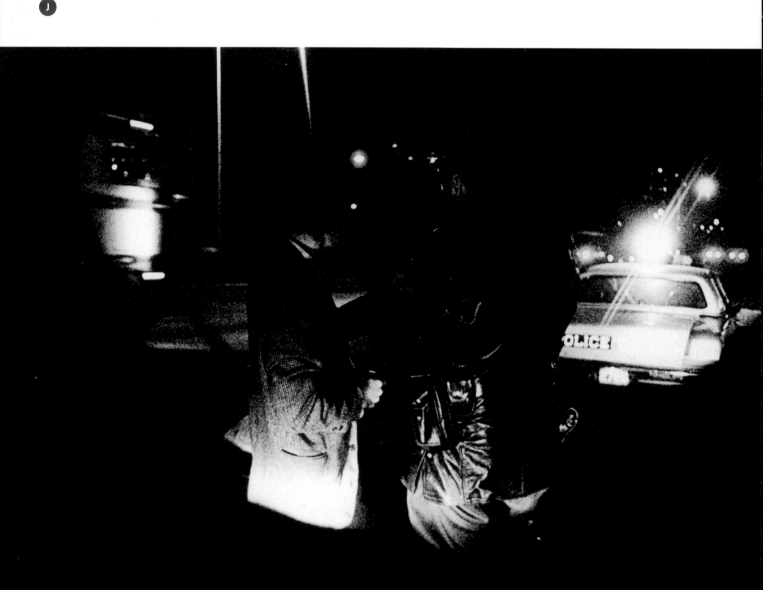

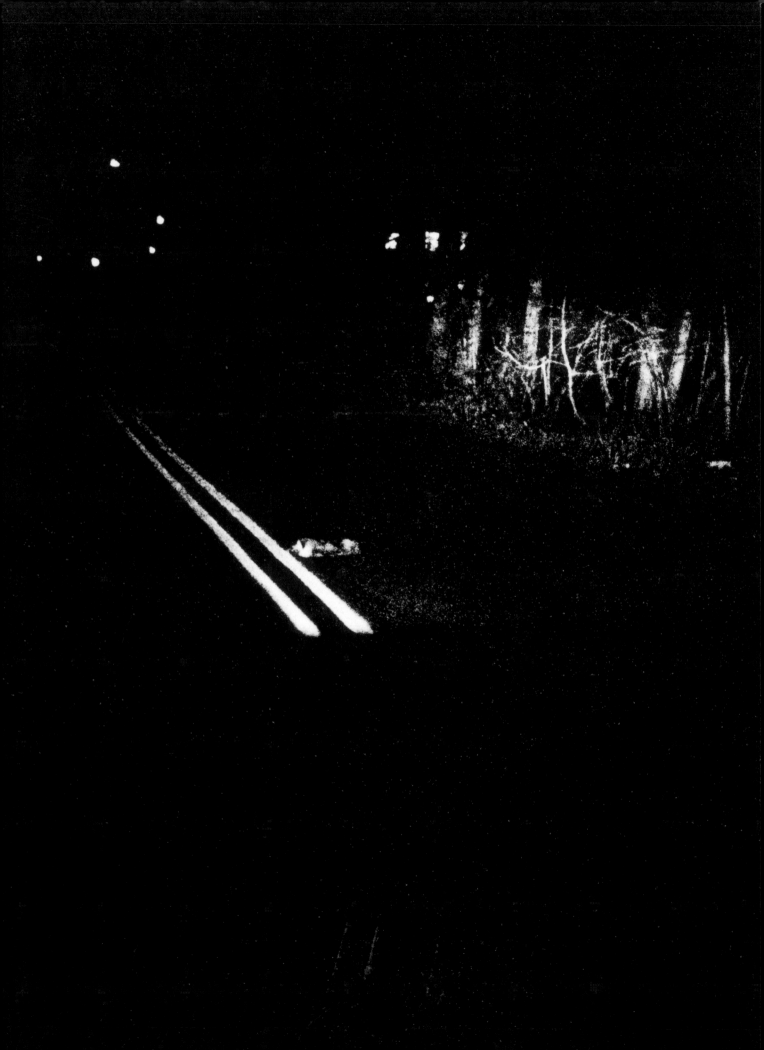

The line is one of David's favorites. Having absorbed film noir's "ramshackle-rickety" syntax, able to "break, dislocate, unhinge . . . , remember only parts of it, irrespective of their original relationship with the whole,"[106] he grafted bits onto *Modern Romance*, giving the series its cinematic illusion of disorientation: "Two cliches make us laugh but a hundred cliches move us. . . . Just as the extreme of pain meets sensual pleasure, and the extreme of perversion borders on mystical energy, so too the extreme of banality allows us to catch a glimpse of the Sublime."[107] The sublime in *Modern Romance* owes its mystical energy to more than film noir. It is inexplicable without television.

HYPNOTIZE WITH ANY T.V. SET

Television repairman's accidental discovery makes anyone a hypnotist right away. Secret method uses ordinary T.V. set. No electronic knowledge needed. No prior hypnotic training needed.[108]

David Levinthal once imagined an exhibition that would feature photographers and their muses—Stieglitz and O'Keeffe, Paul and Rebecca Strand, Harry and Eleanor Callahan. He said that if *he* were permitted to join this pantheon of couples, his mate wouldn't be human. Rather, he'd be accompanied by his television set. He was only half kidding. "LSD and Tantric Yoga" were nothing. To this Californian, T.V., his most enduring muse, was also his drug of choice.[109]

No matter how much he complained that the hypnotic habit was wasting his life ("No television, the clawing wasteland that is so seductive."),[110] the truth is that like big-screen movies, television not only proposed an array of what being American was all about ("Soap operas are documentaries."),[111] but as the pulp-magazine ad promised, it could exert magical powers.

David shot many images of *Modern Romance* directly with the SX-70. But he couldn't get close enough. The picture-spitting camera intruded into the constructions. Soon he discovered another means of using the SX-70 that gave him greater physical and optical distance. It also allowed his own movements more flexibility. Focusing on the setups with a video camera hooked to his T.V., he transposed the scene, as a video still, onto the television screen. Thus he shot, second-hand, from a T.V. image.

He didn't record everything contained within the T.V. screen. He scanned the surface, selecting only portions that he liked. In a wall-papered "hotel" room, he chose a lamp and tufted-velvet armchair, obscuring what might be a female figure nearby (figs. 24, 25). Or is she reflected in a mirror as well (fig. 26)? Differing emphases to scan the same view of people in a diner shifted the mood slightly (figs. 27, 28). By moving the camera to the left of the diner's screened setup, what began as an image of near-incident resulted in something like recollection (fig. 29). The same occurs with people entering a movie theater in blue light (figs. 30, 31). Thus, by screening and then photographing them selectively, his "originals," such as they were, lost all narrative force, with little resemblance to actual time.

The experience is American, "something . . . beyond us all."[112] Living in Las Vegas while he taught photography at the University of Nevada in 1975-1976, he'd fallen in love with the hermetically sealed casinos of this twenty-four-hour adult Disneyland with no clocks and airport walls hung in red velour. "I live here so nobody can get to me," someone in a realtor's office told him.[113] The actors, stand-ins for David, himself in the photographic theater, seem to say the same thing.

The selective light and shadow of the original setups of *Modern Romance* smothered detail. Converted into the electronic web of television transmission, the scenes became strangely oneiric, like the visual fields of surveillance cameras in elevators, apartment vestibules, underground parking garages. Absolute voyeurism, like the plastic dollhouses. But the figures are no more attainable than fish in an aquarium. Thus these interiorized dramas, now more abstracted and distant, suggested greater psychological complexity in being virtually ungraspable except as discontinuous visual signifiers, without origin or outcome.

Nowhere is this more potent than in the video-still bedroom scenes. Their implicit drama is at the core pulp-fiction: "He's leaving! I'll . . . never see him again! . . . The very nearness of him . . . the touch of his hand . . . why do they thrill me so?"[114] But the cliché is enacted in such obscurity that it is impossible to determine what is going on. Filling in the gaps, we find ourselves moved by nothing more than shreds of shadow. A nude woman is on her knees before a fully dressed male (figs. 32, 33). Retaining the man's position and placing the woman on a bed (figs. 34, 35), David shifted the drama to another aspect of despair that has abandoned allusions to popular culture, entering instead a mythical realm of archetypal leave-taking.

In the T.V.-generated photographs of *Modern Romance* every player becomes an underworld swimmer, entering a movie theater in blue light, sitting in a diner, on the subway, at a desk. The many variants of each scene are the strongest declaration of the artist's purpose. In no other work before or since this series would he so thoroughly test the emotional implications of visual illegibility. As he made miniature even more minute within the SX-70 frame, he also took obscurity to the limit, insisting that first, we must feel what we are trying so desperately to see, and that this, itself, was a legitimate kind of reading.

"I seem to have fallen into a trance, an inactive, unproductive trance; doing nothing. Thinking from time to time but in fact doing nothing. . . . Reading the paper I transpose myself, seeing a movie I do the same, even watching television."[115] Lamentations aside, the mental fog imposed by his debilitating muse not only protected him from real life. In *Modern Romance*, it allowed him to surpass romantic longing for the unattainable love that had initially inspired the pictures. The photographs, full of feeling, visualized not only what it is to be lost. They encapsulated stupor, the inability to feel anything.

THE FAMILY IDIOT

Stupefaction was seductive, and he was its willing victim. It may have frightened him, but he wasn't the first artist to assume psychic passivity as a tool of survival or creative springboard. In a five-volume biography of Gustave Flaubert, Jean-Paul Sartre, attempting to chart the path of the writer's early acquisition of language, fixed on one startling fact: at age seven Flaubert still couldn't read. This worried his successful family. Was it stupidity or something else?

The little boy is looking for a way . . . to slip away unnoticed, sheepishly down the drain. Briefly, the aim is not quietism, it is stupefaction, the presence of the soul in the body, which is so muddled that it could well be called absence. . . . Inertia, laziness, inner torments, lethargies– . . . Taken together they define a strategy, . . . in the depths of his physical organism that makes surrender easier.[116]

Gustave's "problem" in becoming an artist was to separate his peculiar style of knowing from that of a wealthy family of liberal scientists, beloved and respected by all of Rouen. Slaves to intelligence, the physicians Flaubert–Gustave's father and brother–didn't produce anything new; understanding everything was enough. Like the incipient writer, David abandoned understanding, relying on his gaze to make his escape for him. Perception became a way to negate all real substance in order to attain the creative benefits of the void.[117]

Creating *Modern Romance*, the photographer contrived a means of having visually incomprehensible emptiness convey sexual longing. If television led to useless, muddled lethargy, it also effectively disconnected him from everything he'd been taught, everything behind the indisputable success of his family. Perception by itself didn't resolve anything. Maneuvering playthings–"Didn't we give you enough toys when you were a child?"[118]–led to simulations of war, sexual intrigue, crimes, paranoia, clouded urban crises, visions of unfulfilled lust. Choosing "my small private world of work that exists here and here alone,"[119] like Flaubert, this artist was another version of the family idiot.

HONEY I AM RED MEAT!

American comedians, like Lenny Bruce or Jackie Mason, have exploited the dilemma of *schlock* versus moral rectitude and made it Jewish, as have certain Jewish writers. Philip Roth in *The Anatomy Lesson* has Nathan Zuckerman give up writing serious novels to create *Lickety Split*, a pornographic magazine. "I want my readers to know that they shouldn't feel self-hatred if they want to get laid. If they jerk off . . . they don't need Sartre to make it legit."[120] Zuckerman doesn't stop. Serious people are driving him crazy.

I'm a sellout to the pop-porno culture, you're the Defender of the Faith! Western Civilization! The Great Tradition! The Serious Viewpoint! As though seriousness can't be as stupid as anything else! . . . I'm "fashionable," you're for the ages. I fuck around, you think.[121]

Hitler Moves East alludes to historical events, but its images don't think. Neither do those of *Modern Romance*. Despite the labor behind their making, they offer no ready means of being understood. Their deliberate vagueness conveys an inner kind of knowing, a recognition of collective emotions that result from fixing on the hunger in virtual emptiness. The artist had never taken such a risk. From then on its implications would be the only path worth following.

Consider a platinum-blonde Barbie doll with a bubble cut, photographed ten times original size with 20-by-24-inch Polaroid sheet film (fig. M). All the more empty for being so clearly rendered, the face is as impassive as that of a Buddha. Barbie's inscrutable self-obsession, now gigantic, becomes a mirage. Size functions exactly as it had with the miniatures of *Modern Romance*. Too large now, it is similarly out of this world. Pondering Barbie, eternal clotheshorse, narcissistic insomniac, we may project onto her physiognomy a collection of expectations, prayers, desires.[122] Thus a spurious artifact of popular culture, despised by the "Serious," adored by children and adults for whom childhood means surrender to emptiness that generates dreams, assumes the status of a seer.

Equally, the juicy red lips and bug-eyed masks of the figures photographed large for *Blackface* may have seemed terrifying to a black writer programmed by racial politics (fig. N).[123] But it was never David Levinthal's intention to depict black rage with objects known to contain violently assertive white rage against blacks. Like Bill Cosby, Oprah, and many other blacks who collect artifacts like those photographed in *Blackface*, David is "a lover."[124] Politically naive, perhaps. The strategy remains that of a consummate player, deadly serious in a contemplative game that leads to undefinable understanding, but understanding, nonetheless.

Recognize the existence of the artifact. . . . Recognize the spuriousness of the empirical world, generated by the artifact. . . . Grasp . . . that the artifact has by its world-projecting power enslaved us. . . . Recognize . . . that the artifact, although enslaving us in a counterfeit world, is teaching us.[125]

Consider pornographic ceramic dolls, deftly painted. Aggressive, bestial, sado-masochistic, crass, obscene, they are polar opposites of Barbie's benign, ladylike aplomb. But they function similarly as thresholds into dreams. Enlarged to 20-by-24-inch Polaroid sheet-film scale, selectively lighted to be read in aspects, these inhabitants of a *Triple X*-rated world live in a spectral reality, raw and female-feral, in which no male can hope to compete (figs. O, P). Legitimate heirs of *Modern Romance*'s darkest corners, they explode its vaguer fictions into fantastic declarations of open sexual combat: "The first time we had dinner and I offered her a piece of my steak she said, 'I don't eat red meat,' and I felt like saying 'Honey, I *am* red meat!'"[126]

Triple X is likely to be as misunderstood as David's rendition of *Mein Kampf*. Witnessing such naive play with corruption may be too much to bear. Yet the artistic strategy is nothing more than the traditional mischief of the trickster, whose age-old role of transgressor has always been to force the truth. Appetite: "If there is to be change, a hungry thief must sneak in from the shadows to get things going. . . . 'He'll eat everything on the buffet. He'll overturn the tables. He'll piss in the wine.'"[128]

EUGENIA PARRY

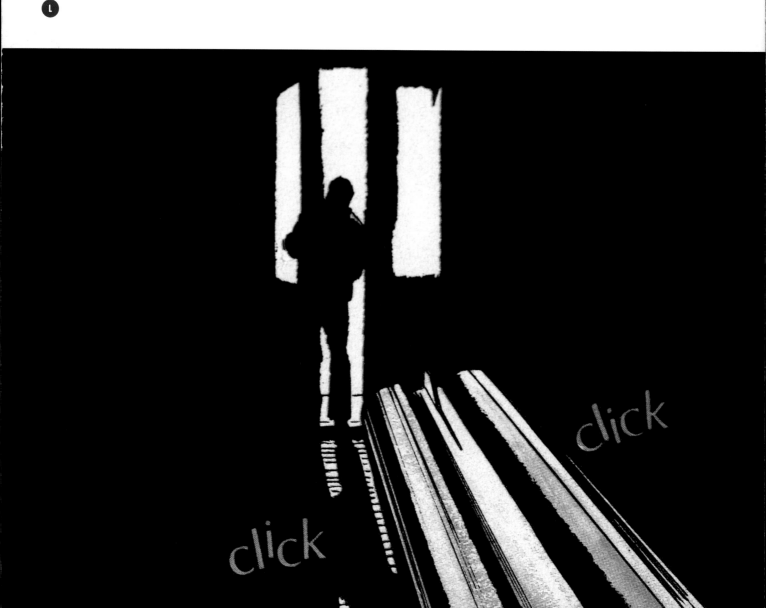

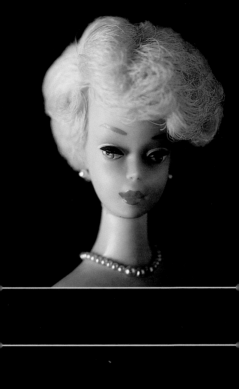

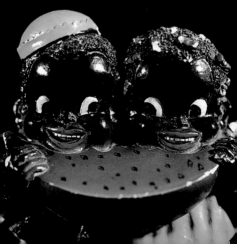

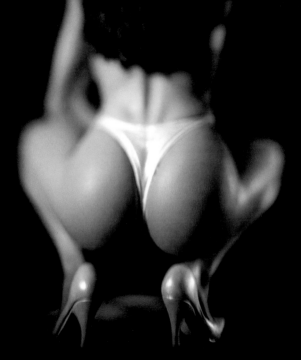

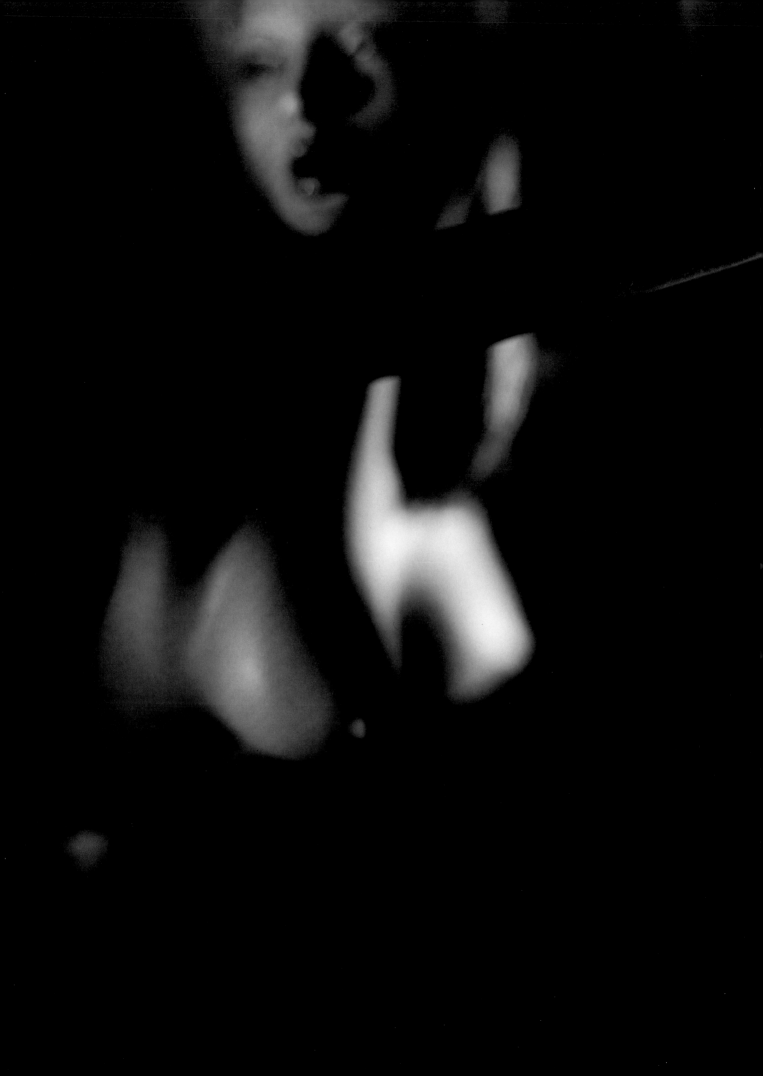

MODERN ROMANCE

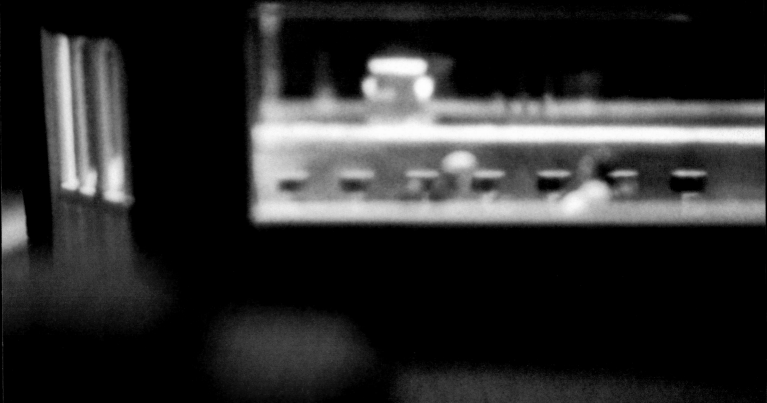

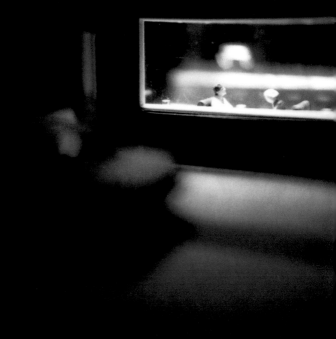

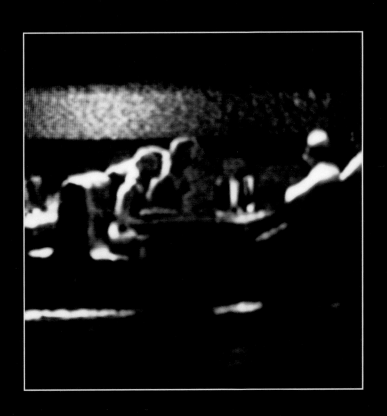

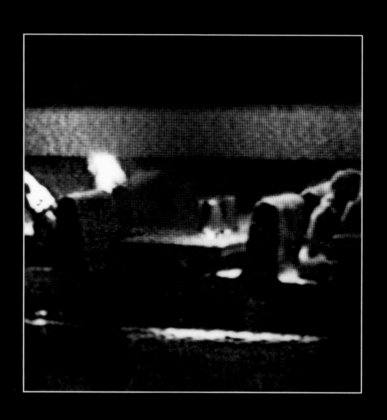

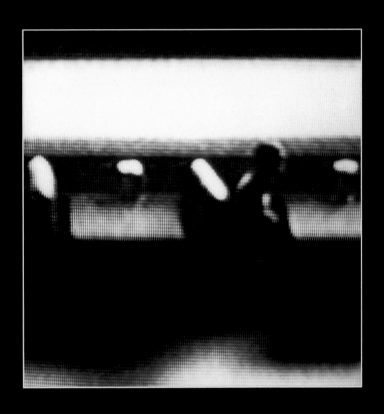

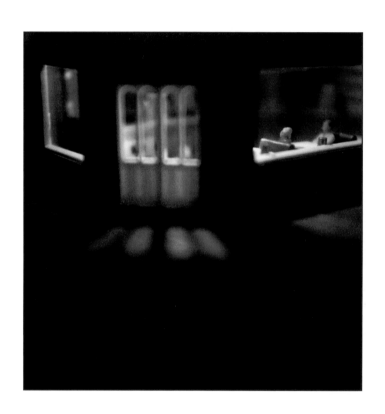

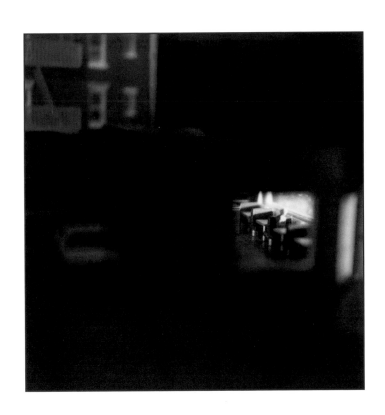

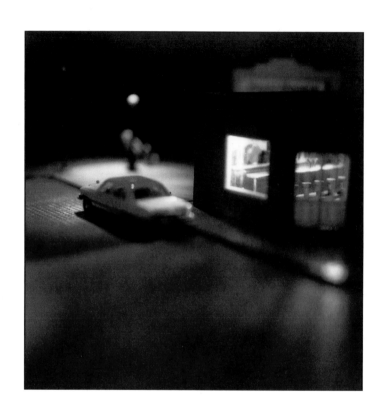

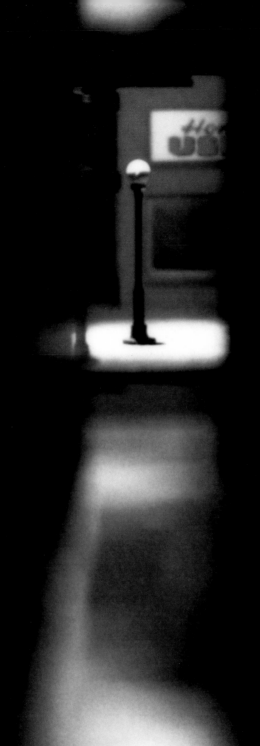

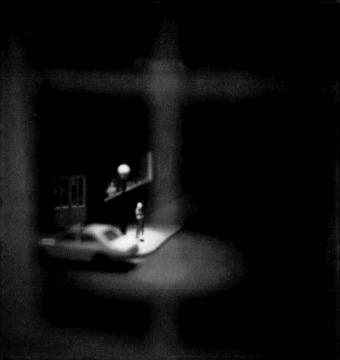

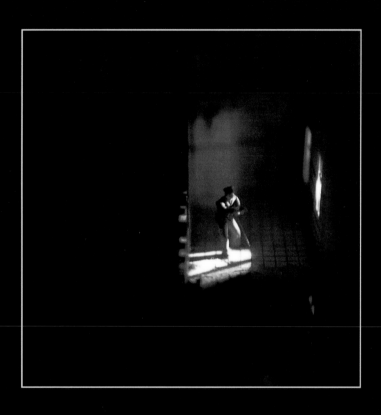

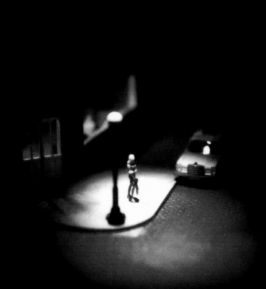

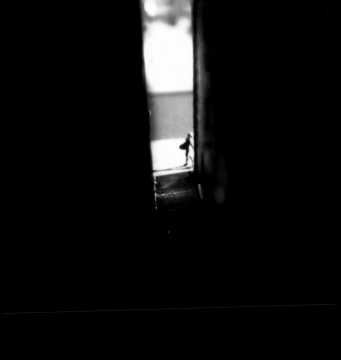

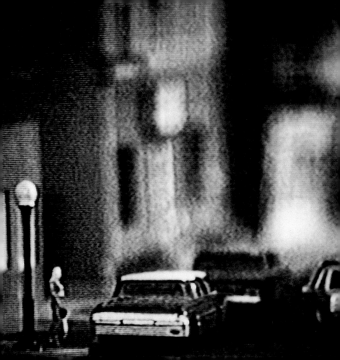

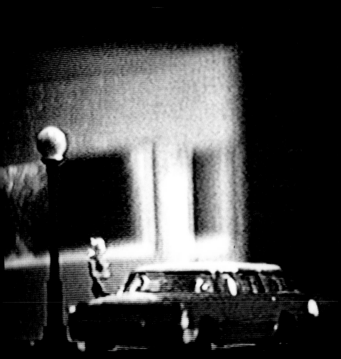

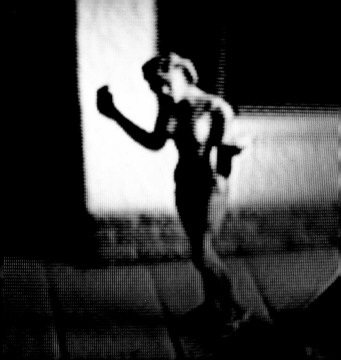

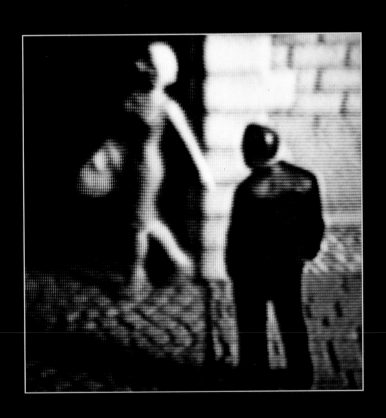

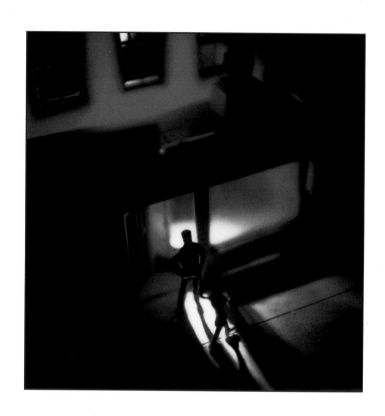

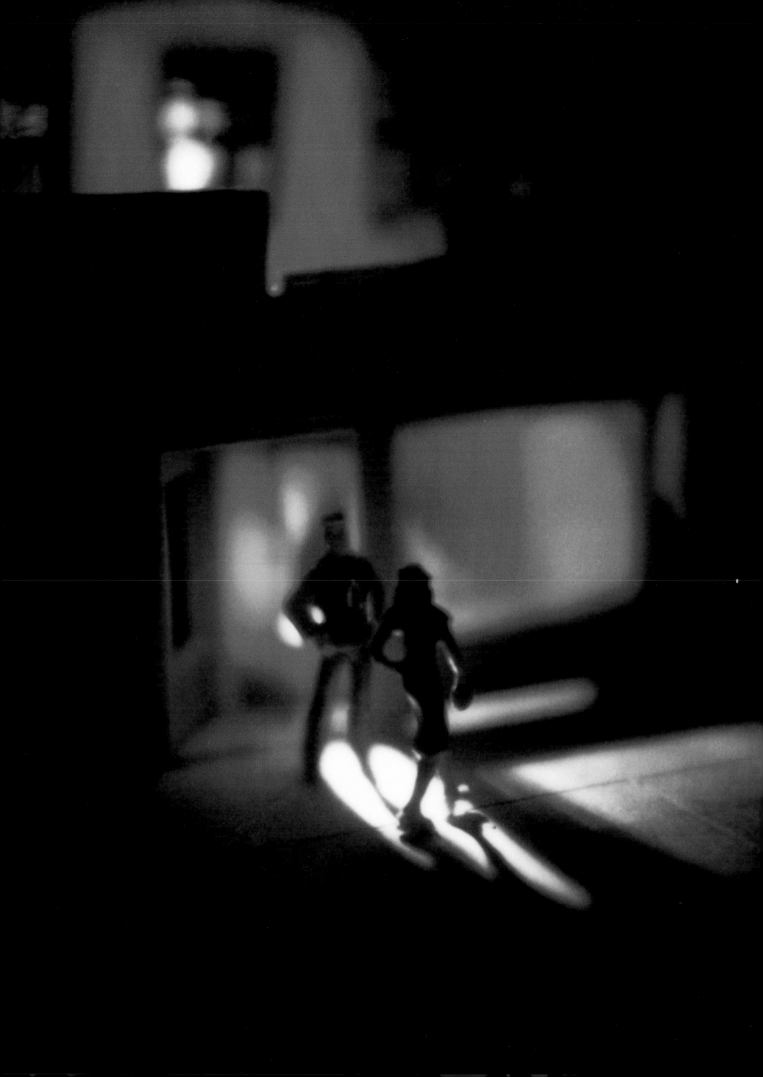

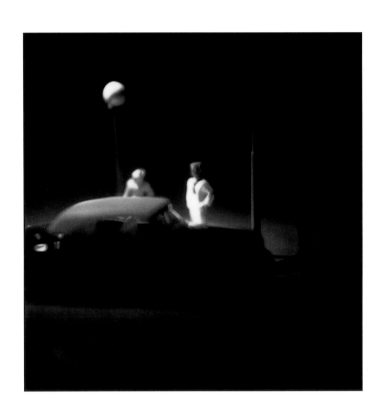

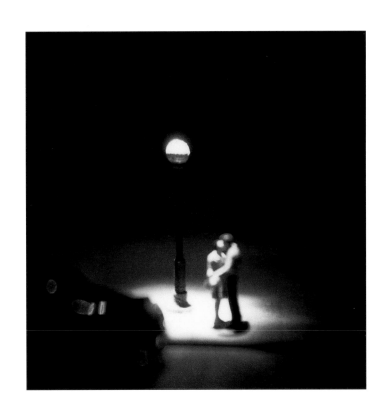

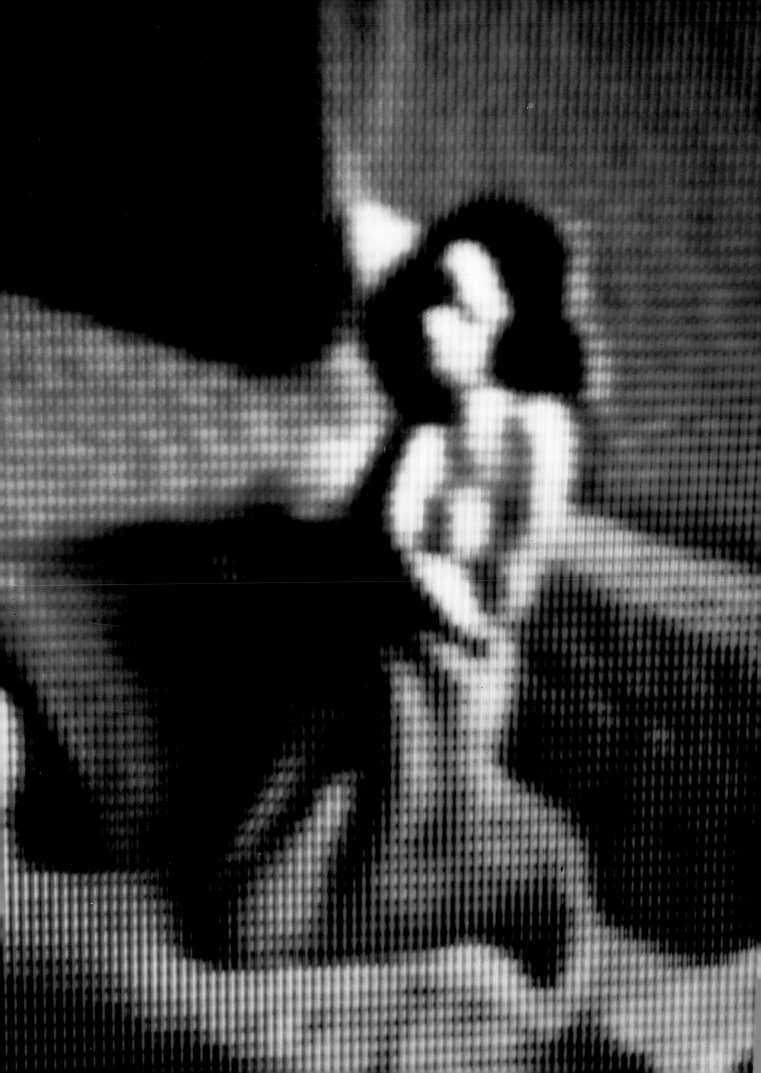

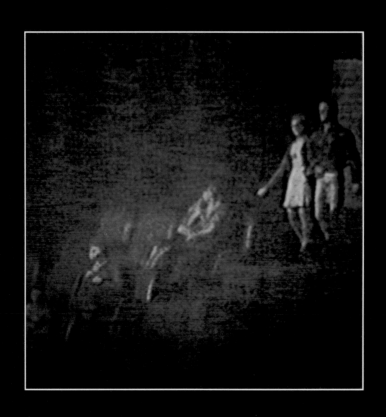

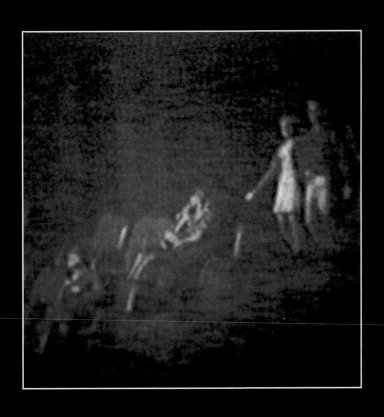

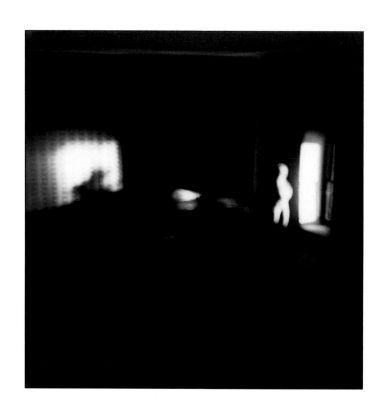

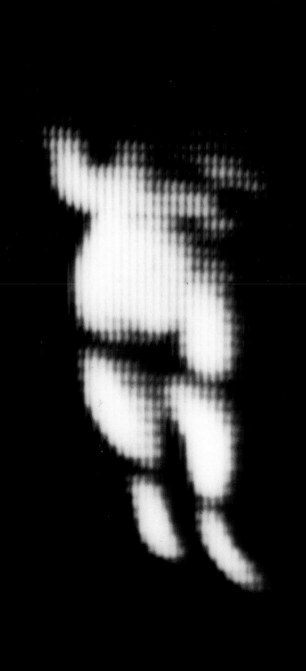

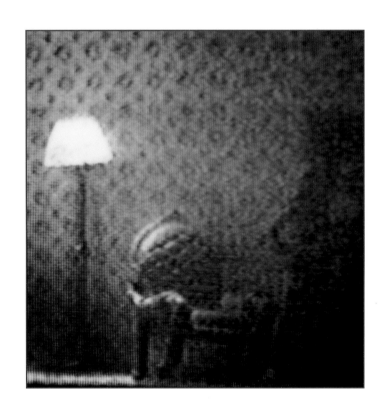

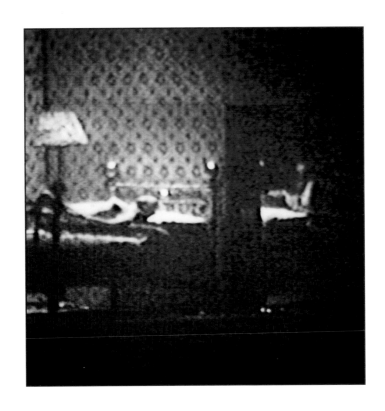

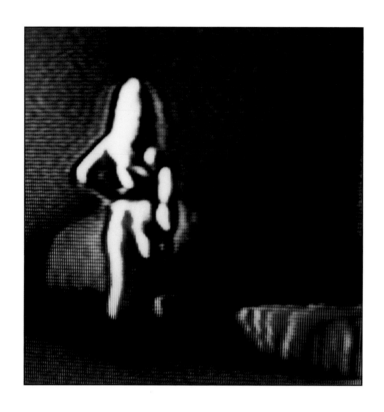

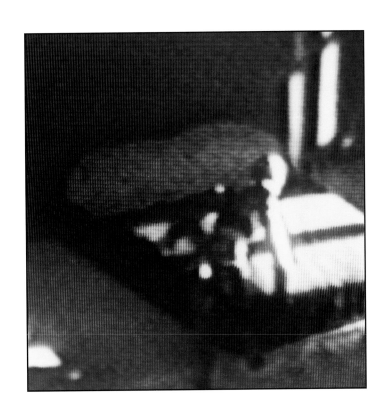

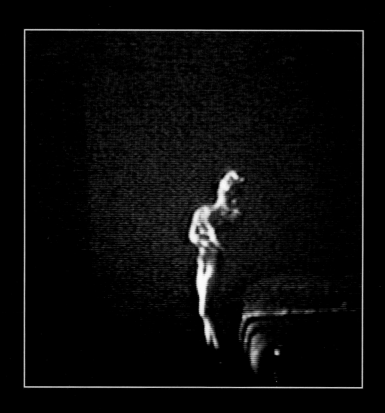

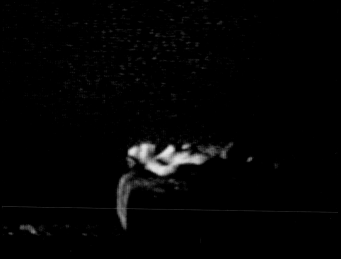

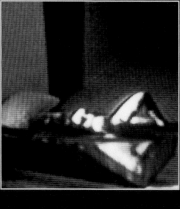

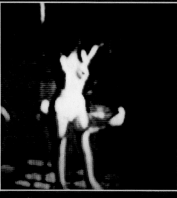

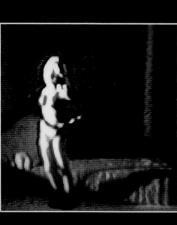

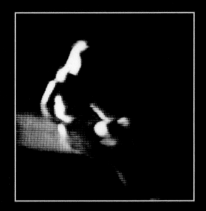

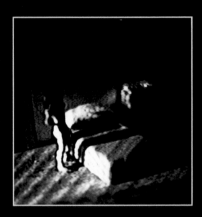

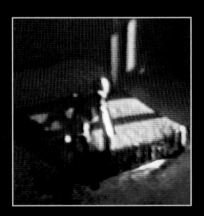

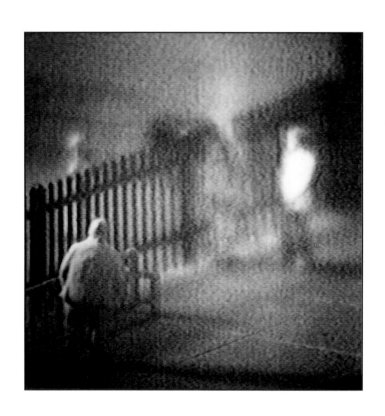

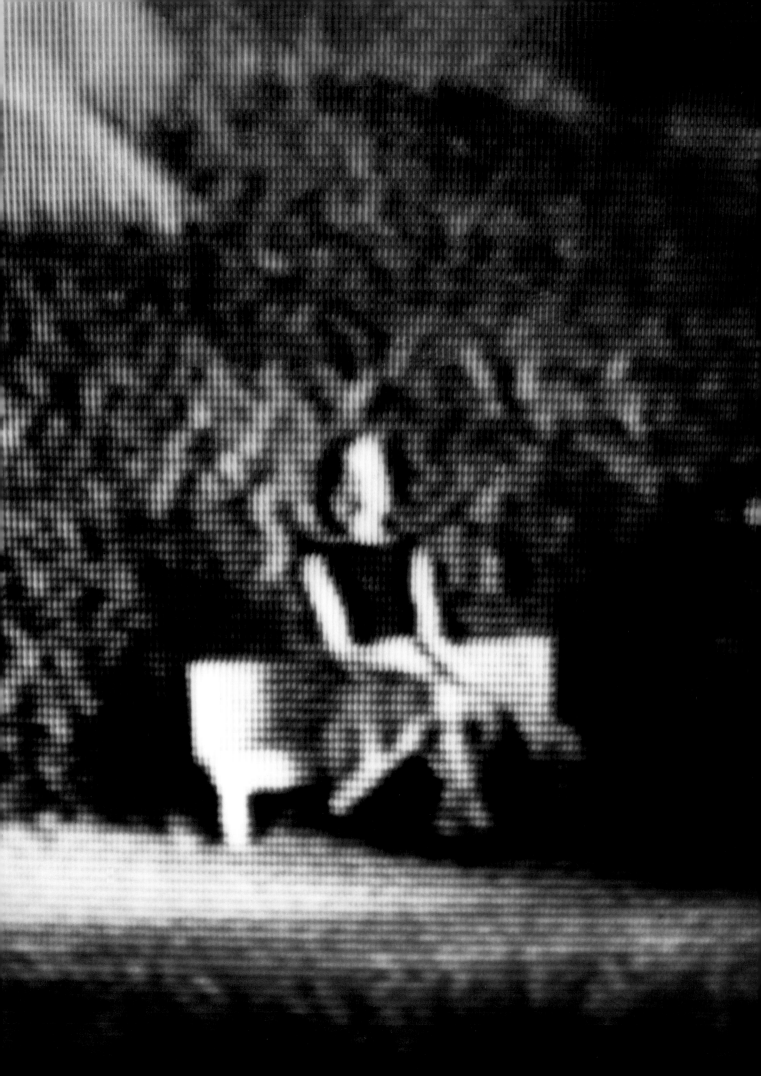

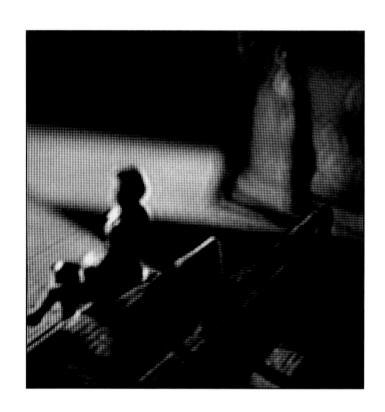

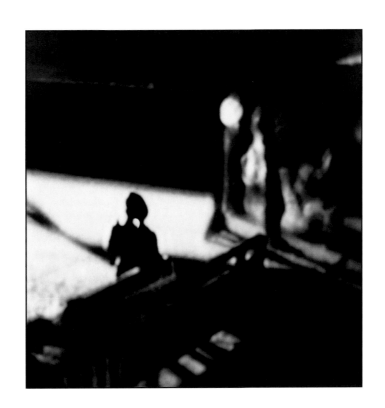

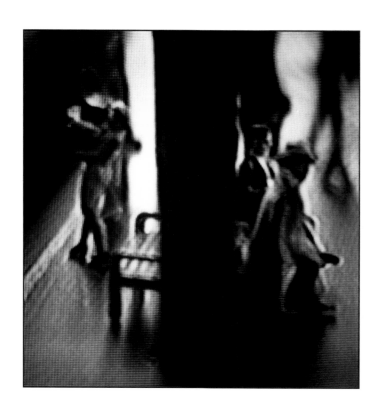

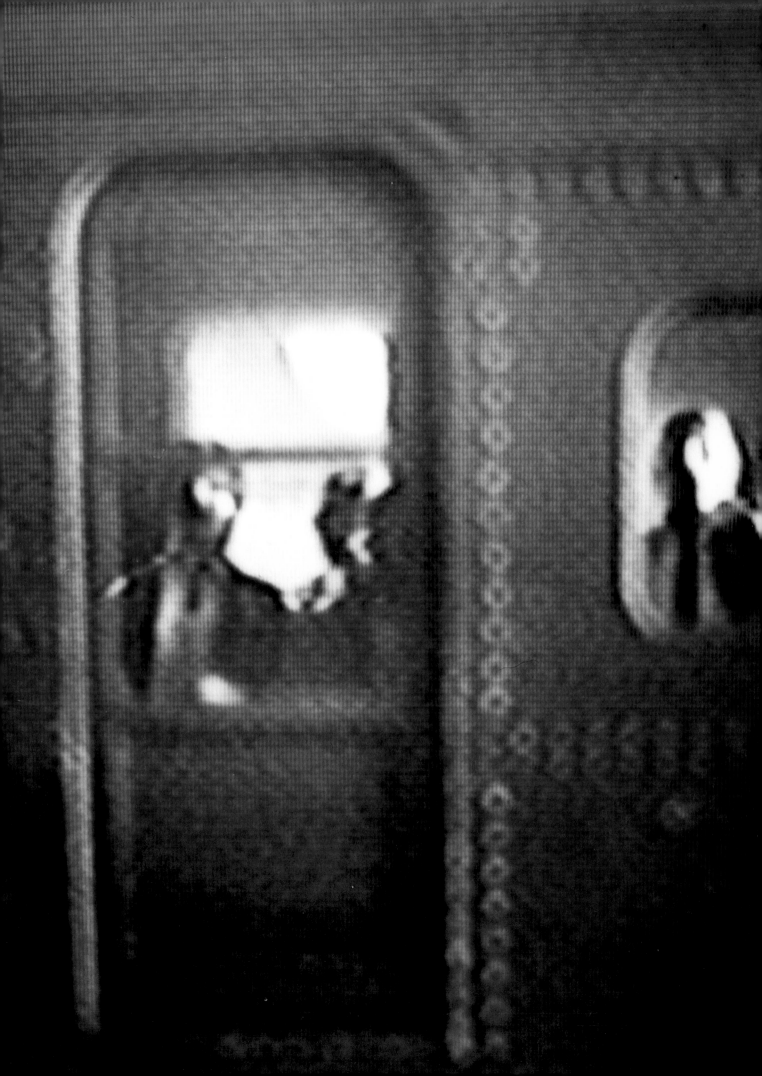

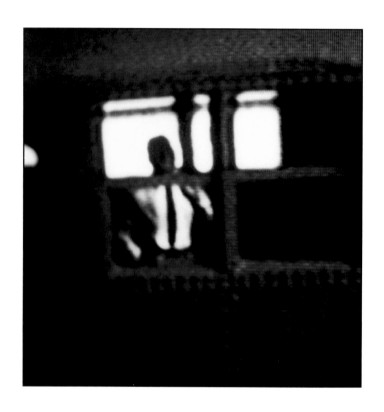

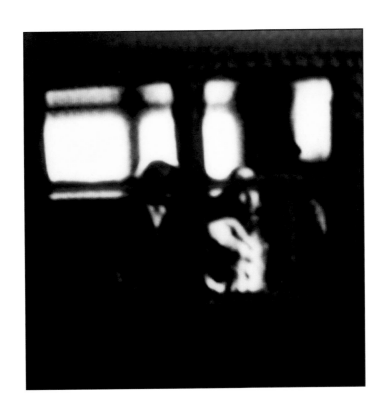

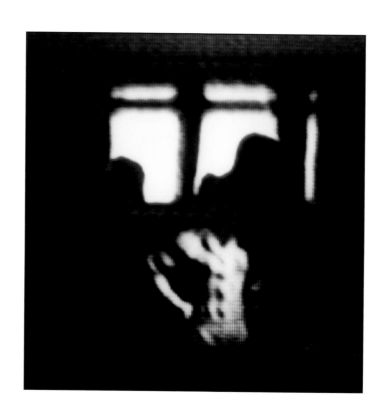

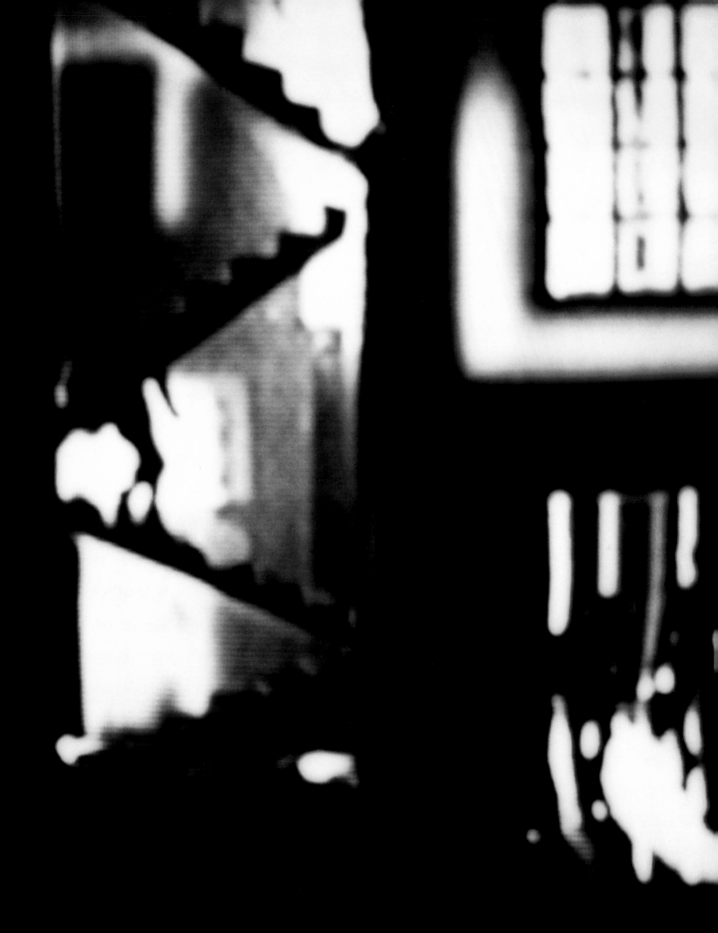

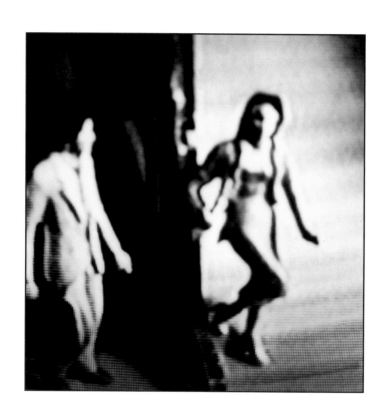

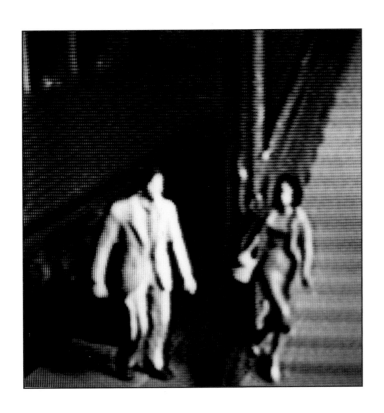

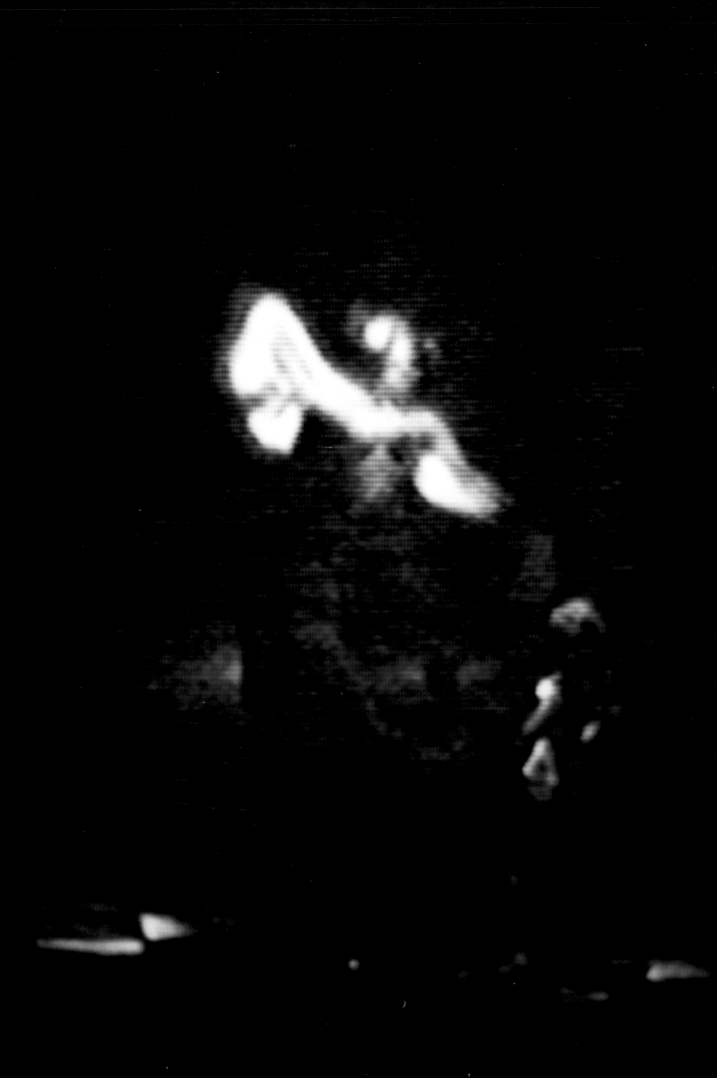

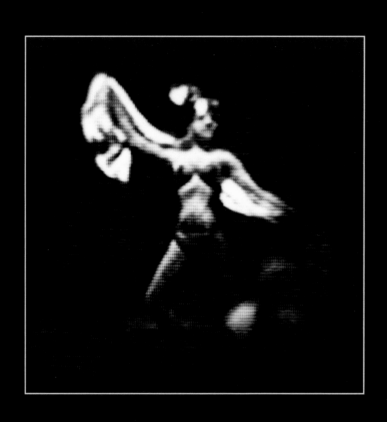

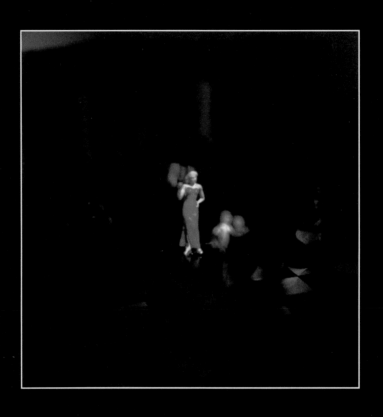

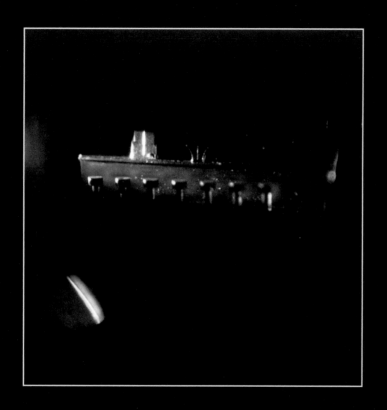

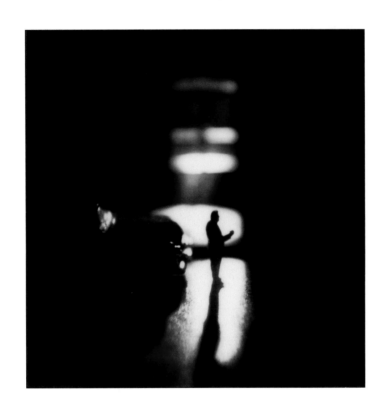

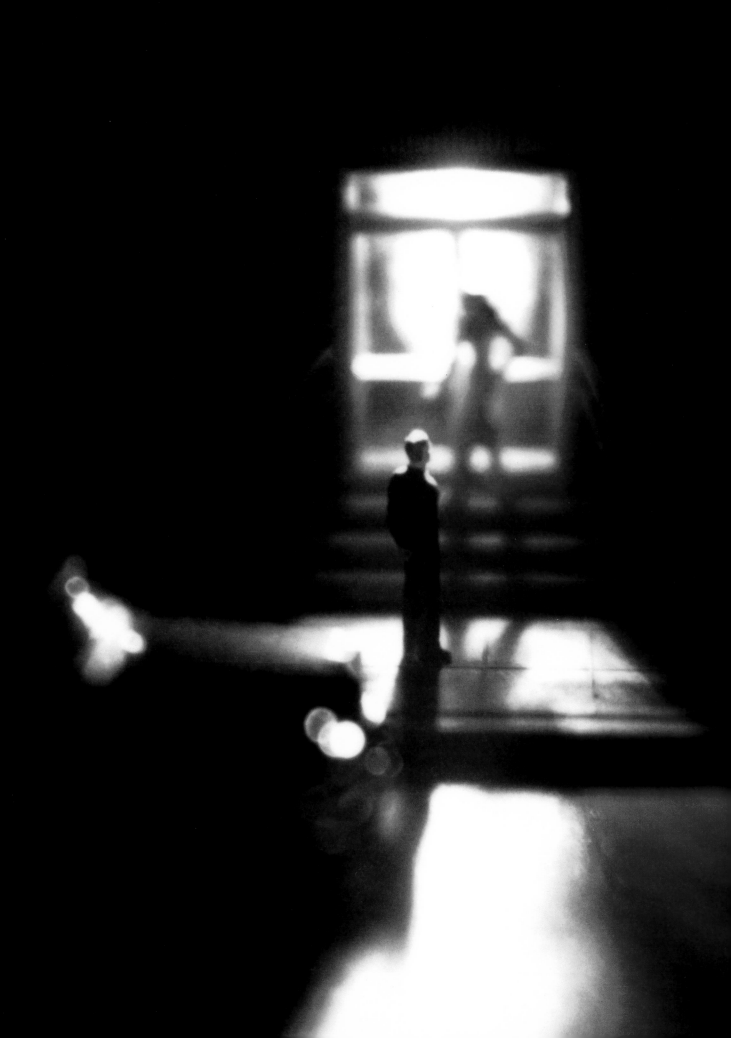

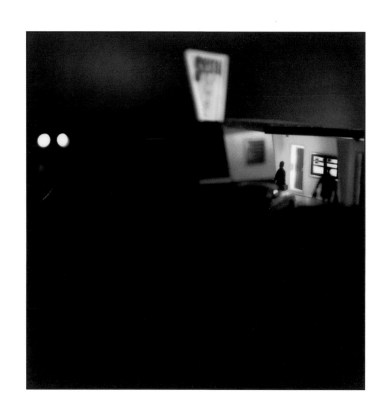

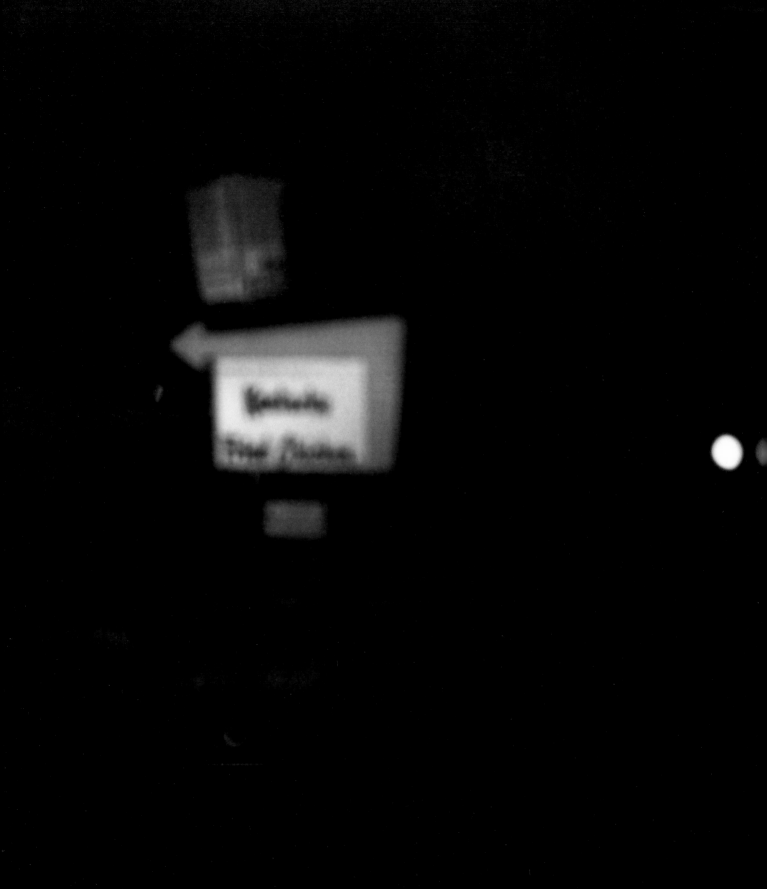

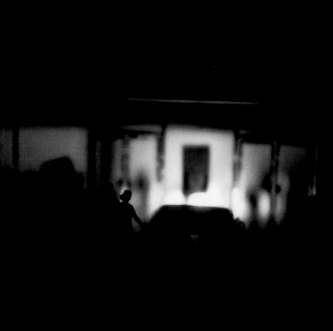

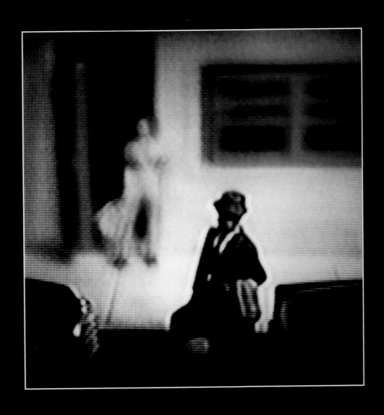

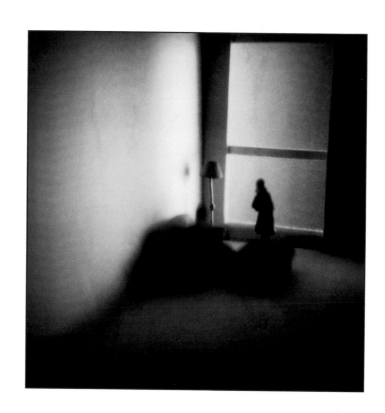

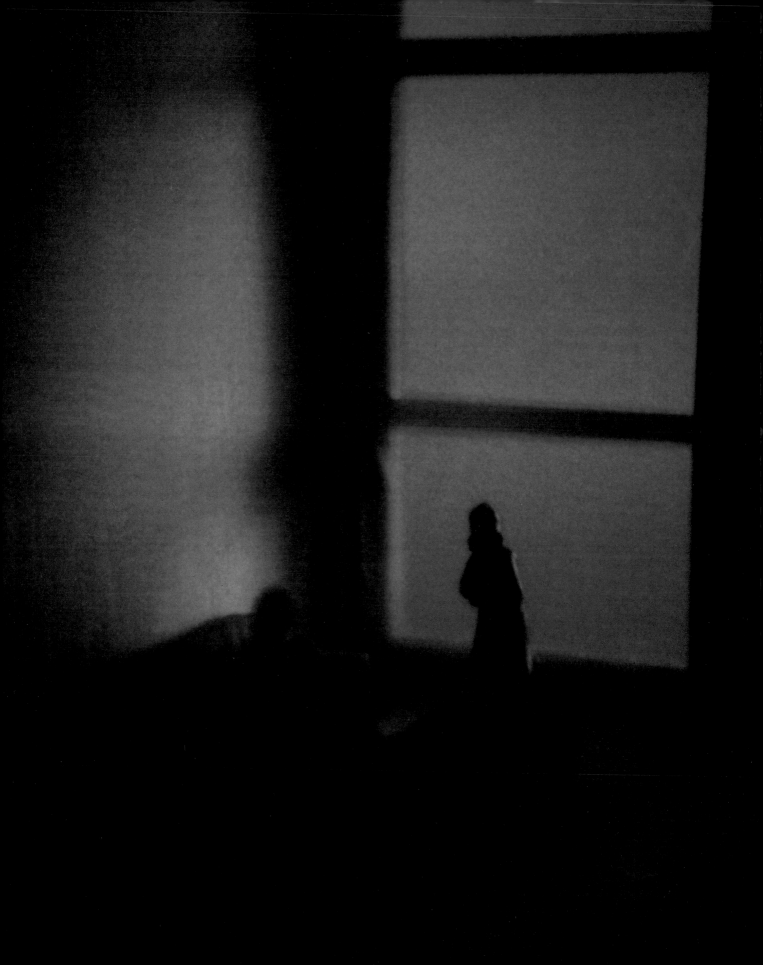

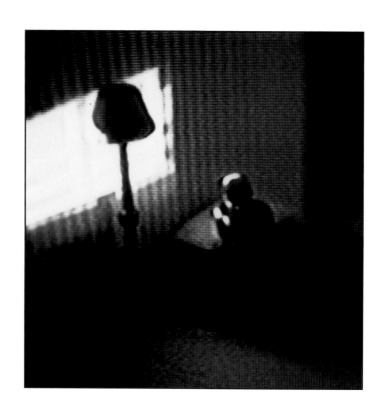

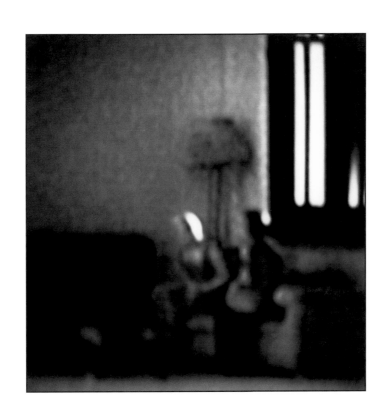

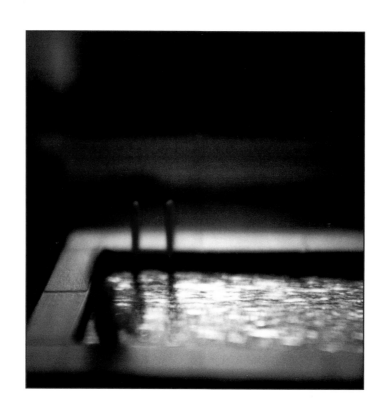

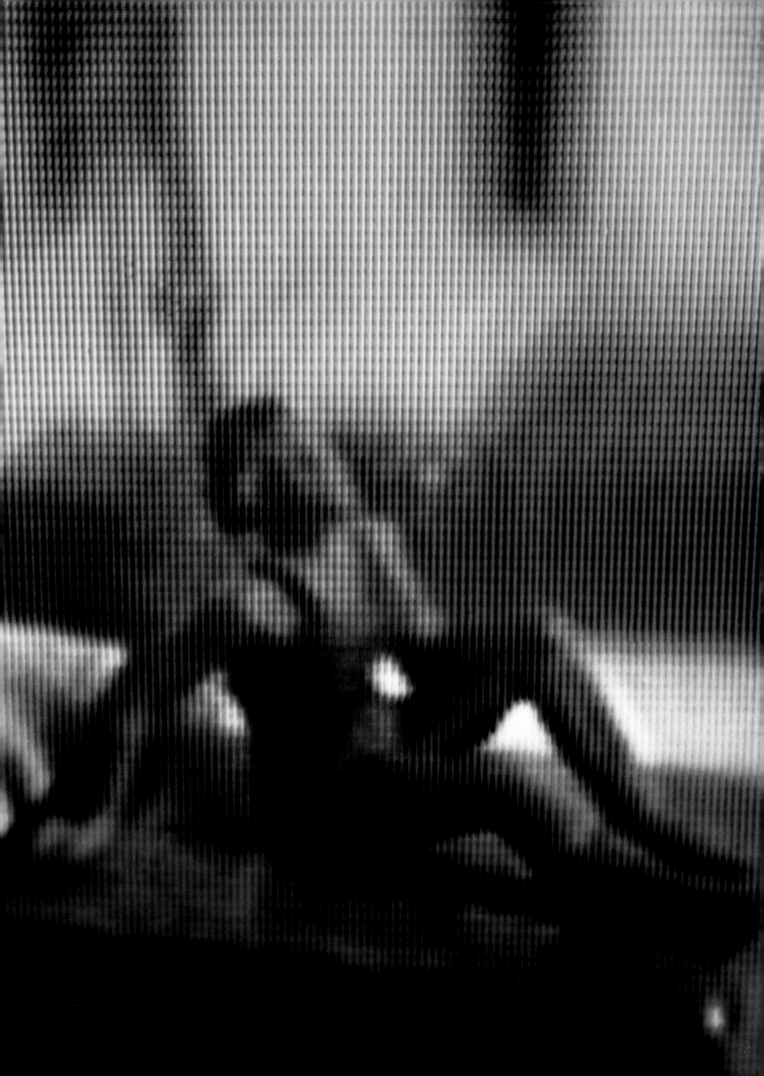

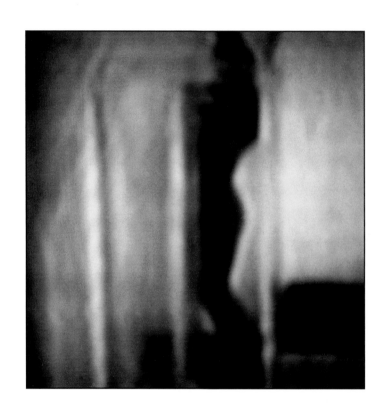

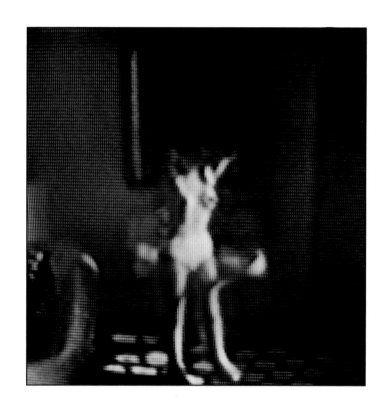

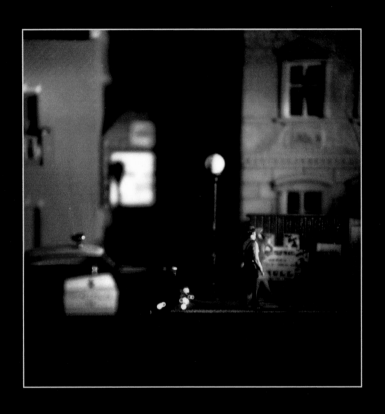

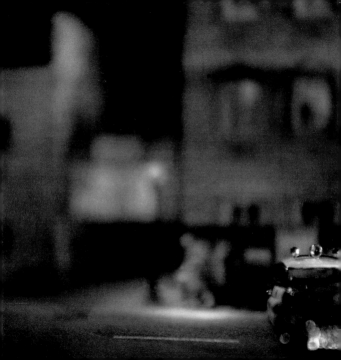

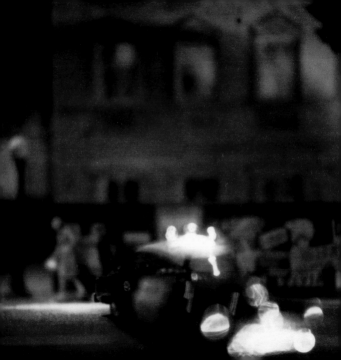

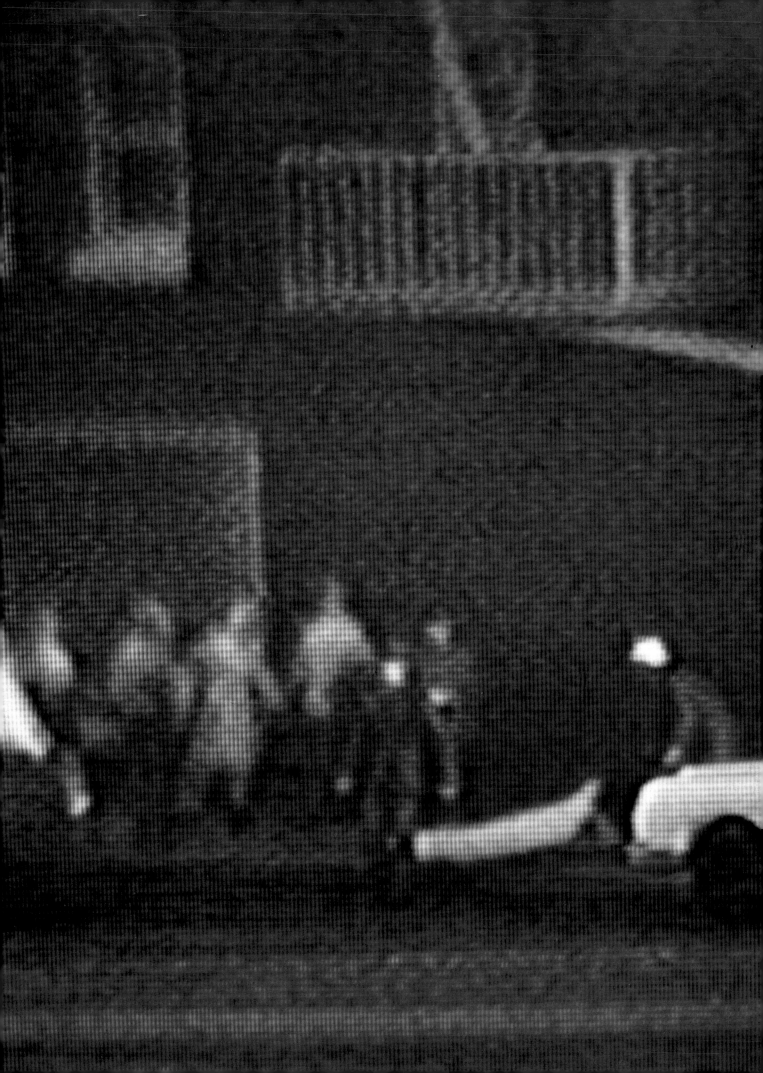

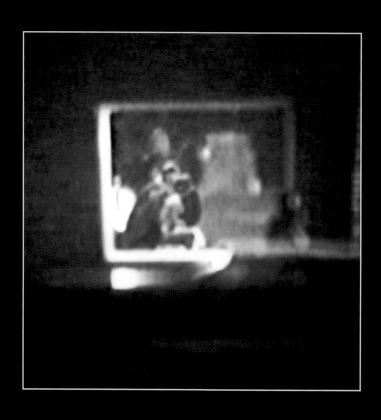

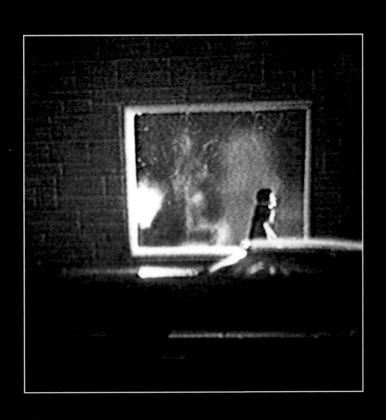

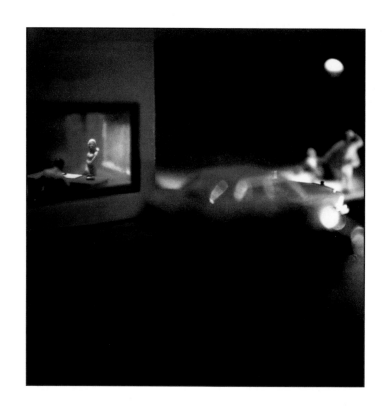

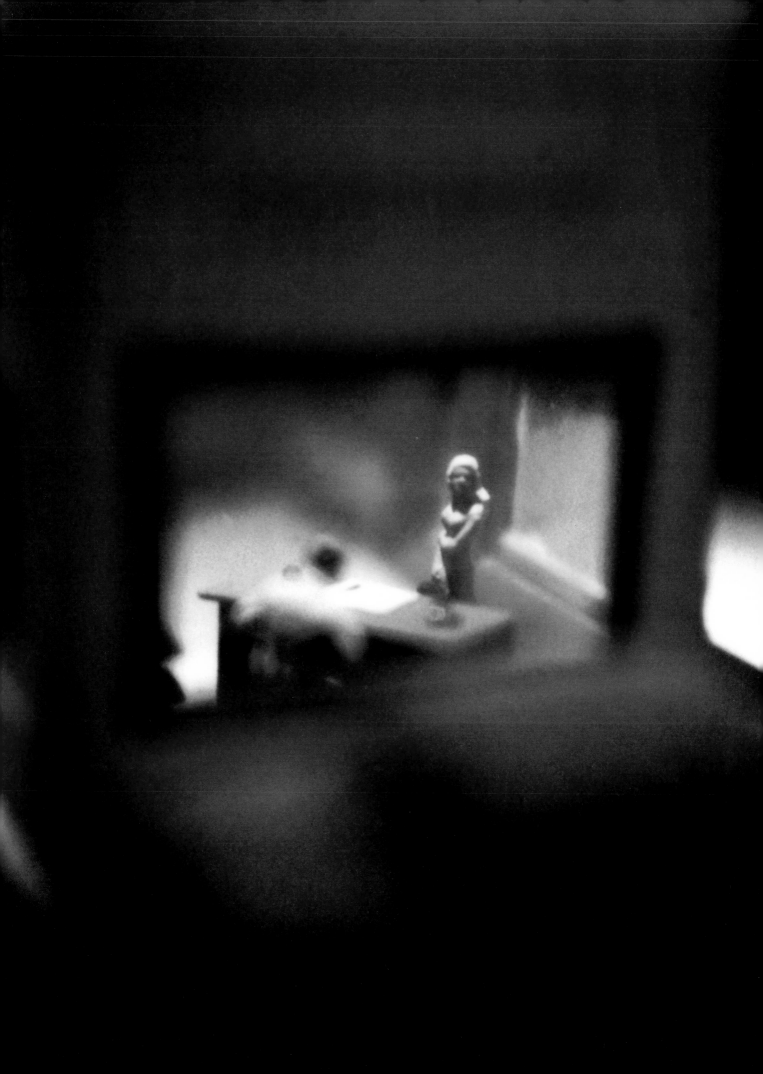

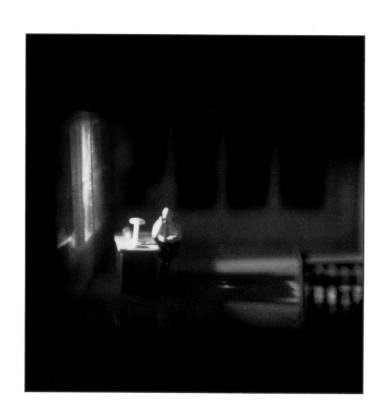

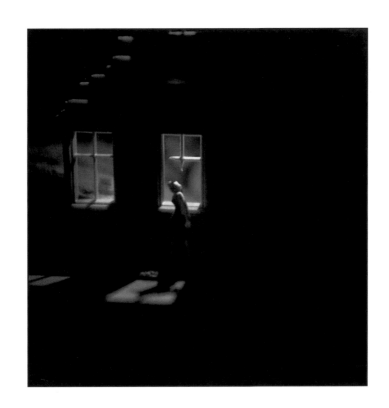

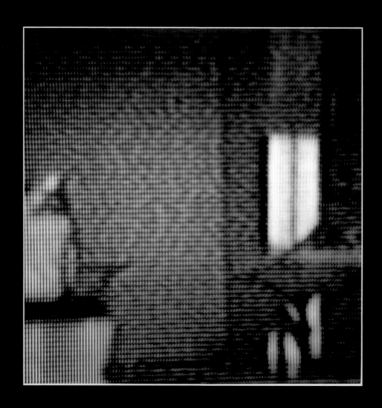

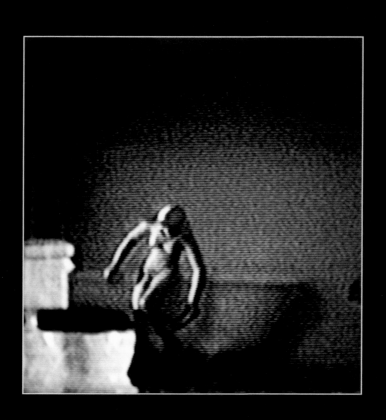

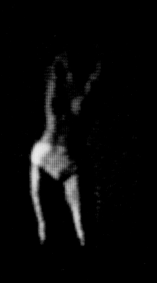

Published by

St. Ann's Press, Los Angeles

Printed and Bound by

EBS, Editoriale Bortolazzi-Stei, Verona, Italy.
Printed on Xantur

Book Design by

Paul McMenamin

Photographs Copyright

David Levinthal

St. Ann's Press

P.O. Box 69212, West Hollywood, CA 90069
Telephone : 310.289.7791. Facsimile : 310.474.6358. Website : www.stannspress.com

Distribution

D.A.P. / Distributed Art Publishers,
155 Sixth Avenue, Second Floor, New York, NY 10013, USA
Telephone : 212.627.1999. Facsimile : 212.627.9484

First Edition, 2000. ISBN : 0 - 967 - 1744 - 1 - 4

Acknowledgements

I would like to thank Robin Hurley and St. Ann's Press
for their constant enthusiasm for this project.
Paul McMenamin's superb design and Eugenia Parry's
thoughtful and insightful essay have both added
immeasurably to the quality of this book.

Sue Medlicott's excellent production work
along with the contributions and encouragement of
Mark Magidson, Deborah Stone, Tom Ireland, Vicki Harris and
Susan Edwards all enhanced this project.
I would also like to thank Sharon Gallagher and Avery Lozada
and all of the staff of D.A.P. for their support.

Finally a special thanks to Elizabeth Glassman who always believed in this work.

D.L.

Kelly Green 1 The Go-Between by Stan Drake and Leonard Starr
reproduced courtesy of Dargaud International Publishing Inc. @1982.

Limited Editions

Two deluxe editions of this book are also available:
The Limited Edition includes a 10 x 8 Cibachrome print, in an edition of 100.
The Vintage Edition includes a unique, vintage SX-70 Polaroid print,
and the Cibachrome, in an edition of 25.

Both editions are signed and numbered by the photographer,
and are slipcased with the book.

If you would like further information on these editions,
please contact St. Ann's Press, or visit the web site.

Exhibitions

In conjunction with this publication, a travelling exhibition, entitled "Modern Romance,"
is being distributed by The Speed Art Museum, 2035 South Third Street,
Louisville, KY 40208. Telephone: 502 634 2964.

notes

. David Levinthal and Garry Trudeau, *Hitler Moves East: A Graphic Chronicle, 1941-1943* (Kansas City: Sheed Andrews &
McMeel, 1977). Trudeau had just won the Pulitzer Prize. Levinthal, confident about the strength of his images, but timid in
the collaboration with a friend who'd become so celebrated, felt he might have been riding on Trudeau's coattails. **2**. Two
hand-written diaries or journals of David Levinthal are rich sources for the many themes of love, loss, isolation, and
estrangement in *Modern Romance* One dates from 18 February 1974 through 20 August 1977, pages unnumbered; the other
dates from November 15, 1982, through September 16, 1991, 1-299 (written only on the odd-numbered sides, which contain
stamped numbers). Hereafter, quotations will be cited as *Journal* with the entry date, as written. The entry containing this
citation was noted on 4/24/83, 10 p.m., 7. **3**. He passed a restroom with a friend, who remarked, "I'm shocked. You didn't
go in." From conversations between the author and David Levinthal in New York, June 1999. Hereafter abbreviated
"Conversations." **4**. Ibid. "Art is timeless; we are not. We must ask about the family to know the individual." Guy Davenport,
"Micrographs," in *The Hunter Gracchus and Other Papers on Literature and Art* (Washington, D.C.: Counterpoint, 1996), 301
5. Conversations. **6**. Ibid. **7**. "I will always feel guilt at not being the obvious success that my family would like." Journal, May
8, 1984, 10:37 p.m., 105. **8**. The stunning drawings and rapid-fire text are by veteran, popular draftsmen Stan Drake and
Leonard Starr in *Kelly Green*, vol. 1, *The Go-Between*, 1982; vol. 2, *One, Two, Three . . . Die!*, 1983; vol. 3, *The Million Dollar
Hit*, 1983; vol. 4, *The Blood Tapes*, 1984 (New York: Dargaud International). David Levinthal owns these four "graphic novels,"
featuring the beautiful widow of a slain cop, "all cold and hard inside because of that," who "doesn't like gangsters too
much; she doesn't like cops either . . . she blames them for her husband's death." From "Kelly Green . . . Or Madame
Bovary," prologue to vol. 1, pages unnumbered. Irish and dedicated to vengeance, her quick mouth, great body, and infinite
social mobility clearly made her an eighties superwoman. **9**. Raymond Chandler, *The Little Sister* (New York: Vintage Books,
1989; first published by Houghton Mifflin, 1949), 135. A copy belongs to the artist. **10**. At the time he wrote in his *Journal*,
"'Life without Linda,' perhaps that is not a bad name for the depressing series of photographs that I am envisioning," entry
for 4.27.83, 10 p.m., 5. This may also refer to the *White Series*—monochromatic rooms with solitary females that he made
nearly simultaneously with *Modern Romance*—which he regards as a kind of prelude to it. "I feel like dedicating the entire
White series to her [Linda], or I could call it Loving and dedicate it to her knowing she would see the depression and the
irony." *Journal*, May 27, 1983, 9:20 a.m. en route to NYC, 11. **11**. "Nostalgia" is #TL236T, from J. R. Enterprises, a division of
Novel Art Creations, New Jersey, copyright 1981. Many materials that David obtained for his sets were not only predestined
for dollhouses but were titled to elicit notions of memory related to small-scale constructions. **12**. Albert Camus, *The
Stranger*, translated from the French by Stuart Gilbert (New York: Vintage Books, 1954), 28-29. Gallimard first published
L'étranger in 1942. **13**. The photographer's *Modern Romance Sketchbook* has 145 numbered pages. Dated and copyrighted
1984, it also contains notes and sketches, made a few years previously. **14**. Conversations. **15**. *Modern Romance Sketchbook*
passim. **16**. Chandler, *Little Sister*, 50. **17**. Called Bend-a-Lights, these small, malleable flashlights with a tiny lamp at one
end could be shaped into any desired angle. They cost three dollars each. **18**. Conversations. He thought of Hopper's work
at the beginning of the *Modern Romance* project. But this soon passed, for as he generated the sets for his pictures, he
began wrestling with memories he couldn't name or definitively identify that prevented any direct or sustained influence
from the painter. That they shared the mood and period-look of Hopper's pictures, he says, was completely coincidental. In a
relatively recent publication on the painter, *The Poetry of Solitude: A Tribute to Edward Hopper*, poems collected and introduced
by Gail Levin (New York: Universe Publishing, 1995), twenty-seven contributors respond in thirty-three poems to Hopper's
work. The poets' contemplations of the paintings, rather than the paintings themselves, more closely parallel the space
and lonely solitaries created by Levinthal more than ten years before. Compare, for example, David Ray's "Automat": "It's
quite classic— / separate tables / brass glistens on, / polished spittoons / and reflected lights / a highway out to hell, /
black as hell. / Extent of human reach, nihil, / and loneliness burning loud / like lamps left on," 54; or W. R. Elton's
"Hopper: In the Cafe": "who are these people / moved by what dream / actors hired for the scene / papier-mache," 57. As
for Walker Evans, in 1974, after David was a graduate student in photography at Yale, his roommate and former classmate
Jerry Thompson, befriended the older photographer, then teaching at the university, who became something of a "fixture"
in the apartment of the two young men. Evans's passion for collecting parts of old cars and other American detritus had
turned their place into a virtual way station before the treasures were taken to Evans's house in Old Lyme, Connecticut. At
the time, Evans was enjoying new renown with the rediscovery of his work, but David sensed he was too angry and bitter to
benefit from the attention. As for David's receptivity to Evans's photography: "I never liked it as much as I thought I was
supposed to." Conversations. Later in this essay, we shall see that when David Levinthal finally photographed his fabricated
sets for *Modern Romance*, he deliberately eradicated any traces of the descriptive completeness associated with Hopper's

...ersions of alienation, choosing instead obliteration with shadows. Needless to say, the prototypical detailing of store-fron or street imagery that earmark Evans's classic documentary style didn't interest him, as such. **19**. Conversations. **20**. Love and passion were "All to no avail. Sometimes I feel like I am a dispassionate observer of myself." *Journal*, 4/27/83, 10 p.m. 7. "Why is it that I want Blake to love me? . . . It has certainly propelled me forward with my idea for the Blake book. It wil be like a personal version of Sartre. That there is a hopelessness in personal relationships the crushing of the romantic spirit." *Journal*, May 1, 1984, 10:33 p.m. **21**. *Modern Romance Sketchbook*, 113. **22**. Geoffrey O'Brien, "Jim Thompson Dimestore Dostoevsky," afterword to *A Swell-Looking Babe*, by Jim Thompson (Berkeley: Black Lizard Books, 1986), page unnumbered. David considers the psycho-pathological world of Thompson one of his most important sources. **23**. Chandler *Little Sister*, 81. **24**. From telephone conversations between the author and David Levinthal, August-October 1999. Davic insists that the story is accurate, though he suspects his family might not remember the details. Hereafter abbreviated Telephone Conversations. **25**. *Journal*, Feb. 18, 1974, 9:55 p.m., pages unnumbered. **26**. Chandler, *Little Sister*, 21. **27**. James M Cain, *Cloud Nine* (New York: Mysterious Press, 1984), 83. The novel, with its atypical happy ending, was written in the 960s, when Cain was seventy-five. David owns a copy of this book. **28**. Author unidentified, "The Art of Kissing," *Young Romance* 22, no. 180 (March 1972): page unnumbered. His sister gave him her old magazines, but the photographer addec others to his collection. **29**. William P. McGivern, *The Big Heat* (New York: Berkley Books, 1987; first published by Dodc Mead, 1953), 78. David owns a copy of this book. **30**. One of these is *Walthers HO 1999: Model Railroad Reference Book* available from P.O. Box 3039, Milwaukee, Wisconsin, 53201-3039, 936 pages, with thousands of illustrations in black-and white and color. See "Instant Horizons," 318-20; "Bums," 322; "Mourners and cemetery graves," 350. A section of thi omnibus, in miniature, called "Welcome to the Magic of Model Railroading," shows color photographs of model train placed in miniature, true-to-life dioramas, achieved by a variety of amateur designers using Walthers's products. The cata ogue features some who have photographed their tableaus as undisputed successes. The images are staggeringly realistic enhanced by accompanying texts that sentimentally evoke a simpler American life of fifty years ago. More important, dra matically, *we are there*, enthralled by a nostalgic world of the small. In a "Model and Photo by William Kupiec," showing a way freight rolling past a "Crow River Crawford Notch station," the text reads: "The fireman has been keeping a close eye on his fire as his train rumbles into town. Seems there have been a lot of complaints from townspeople about cinders ruining laundry. You can bet somewhere along the run, there's an inspector just waiting to catch an unwary fireman! But with th smoke almost pure white from the stack, it will be someone else who gets caught today. . . . Peddlers have arrived from th country with truckloads of fresh vegetables and kids are reluctantly heading for school. Who can blame them on a beaut ful day like this?" (581). Other color photographs of such spectacles, including those of "Magic" award winners, appear on 582-600. Not a few of these use nocturnal lighting, suggesting the effects of David Levinthal's own settings. Of the thousand of products offered in this tome of miniature railroading, David informed me that he ordered, built, and painted the "Fishing Pier," including, with the pier, a ramp and a float (466). As a prop for *Modern Romance* it is much too complete and detailed consisting of hundreds of pieces. Nonetheless, it reveals that the photographer's commitment to miniature allowed him to submit to the discipline of such minute assembling, confirming that the simplicity of figures and settings in *Modern Romanc* was a deliberate dramatic choice rather than a lack of technical competence. **31**. "Oh, the world appears to work smoothl enough, like a toy town where the only business is the constant shifting of goods and wastes. If that were all, how easy to live—buy your food, put out your garbage. But the toys and models and dolls and the world's looks are treacherous. The teach children it will be easy. The real problems . . . are nothing like what children are led to suspect." Josephine Humphreys *Dreams of Sleep* (Harmondsworth: Penguin Books, 1984), 4, 5. **32**. Chandler, *Little Sister*, 79. **33**. Camus, *Stranger*, 42 4. "What is lacking in the suicide scene is realism. I am trying to get too much information into the picture . . . too muc obvious information. . . . What makes the White Series so successful is the implied and unstated feelings." *Journal*, May 27 983, 9:20 a.m. en route to NYC, 11. **35**. "I want to have several scenes going on simultaneously. The bedroom, the outside he interiors and stairways, which I shall draw a sketch of so that I can begin construction." Ibid., entry for December 2 983, 5:52 p.m., 15. **36**. Susan Stewart, *On Longing: Narratives of the Miniature, the Gigantic, the Souvenir, the Collectio* Baltimore and London: Johns Hopkins University Press, 1984), 61. **37**. Gaston Bachelard, "The 'Cogito' of the Dreamer," i *The Poetics of Reverie, Childhood, Language, and the Cosmos*, translated from the French by Daniel Russell (Boston: Beaco Press, 1971), 166. Bachelard is quoting an unnamed German author. **38**. Ibid., 167. **39**. Chandler, *Little Sister*, 21. **40**. McGiver *Big Heat*, 112. **41**. Victor Wild, *How to Take and Sell Erotic Photographs: Secrets of the Masters* (Carpinteria: Californi Wildfire Publishing), 1981, 7. David Levinthal owns this book. He may have followed its precepts. More likely he collected it because the techniques confirmed what he'd evolved instinctively. **42**. Ibid. **43**. Gaston Bachelar

The Poetics of Space, translated from the French by Maria Jolas, foreword by Étienne Gilson (Boston: Beacon Press, 1969), 7-58. **44.** Humphreys, *Dreams*, 2. **45.** Preiser, *Miniaturfiguren, Automodelle. Zubehör für Modellbahnanlagen*, published by Kleinkunst-Werkstatten, Paul M. Preiser GmbH D-91628 Steinsfeld. Haus Nr. 60, Postanschrift: Postfach 1233 D-91542 Rothenburg o.d.T., Federal Republic of Germany, catalogue PK 22, 1996-1997, text from inside cover. **46.** Ibid., passim. **47.** Bachelard, "'Cogito,'" 166. **48.** He continued, "Being with her makes me feel happy, not alone." *Journal*, September 11, 1977 10:23 p.m., page unnumbered. **49.** Cain, *Cloud Nine*, 59. **50.** Wild, *How to Take and Sell Erotic Photographs*, 19. **51.** *Modern Romance Sketchbook*, passim. **52.** McGivern, *Big Heat*, 30. **53.** "I have only my small private world of work that exists here and here alone. . . . I suppose it is . . . my lack of confidence that leads me (I was going to say forces me, but it is not force but a choice) to lead a life of dreams and fantasies. Maybe this is why I photograph what I do. A world of my control where I can revenge myself on . . . cruelty and coldness. . . . Walk away from the fantasy of dreams. Like the dreams of the girl in the elevator, or the girl in the corridor. They are beautiful but what I dream of will never happen, or it will happen only if I don't dream of it happening." *Journal*, April 21, 1984, 73, 75, 79. **54.** Conversations. **55.** The modus operandi has assumed near-mythic proportions regarding this artist: "What do you say to people who ask, 'Why do you play with toys?'" "You mean after I've told them . . . that it's a lot of fun?" *David Levinthal: Work from 1975-1996*, exhibition catalogue, essays and interviews by Charles Stainback and Richard B. Woodward (New York: International Center of Photography, 1997), pages unnumbered. **56.** Which leads to great distortions by those who hope to explain him. David Corey's essay in the exhibition catalogue of David Levinthal's photographs, *Small Wonder: Worlds in a Box* (Washington, D.C.: National Museum of American Art, Smithsonian Institution, 1996), 7-25, epitomizes the guileless response of a critic trying, valiantly, to provide a context for the work but ends up reducing it to a trivial pursuit. Completely disregarding the photographs in question, Corey's postmodernist hodgepodge of American media events, including the history of Marx toys and play sets, is offered, newsreel fashion, as if to imitate, in writing, the postmodernist media blitz that shaped Levinthal into the deft media-blitz manipulator that he is. Corey says of play sets: "We are grateful for these quick reads on where we came from and what we are about" (7). Levinthal may seem deceptively simple, but "quick reads" are not what keep us returning to his work. Such writing, meant to enrich our experience, reverses the effect in making the pictures, by association, seem as emotionally bankrupt as their sources. Also, it unwittingly implies that Levinthal, himself, is equally so. **57.** See Schjeldahl's vitriolic response to Levinthal's retrospective exhibition, *David Levinthal: Work from 1975-1996*. "Down in Flames," *Village Voice* 42, no. 5 (February 4, 1997): 90, is an example of the degree to which this artist's methods can be mistaken for intentions. Schjeldahl, a postmodernist camp follower, shows confusion and rage when he notices one of his artists behaving in ways that don't fit the art-historical category he has created for him. Insisting on Levinthal's work, above all, as "hip child's play," when the photographer used toys to treat the Holocaust in *Mein Kampf*, Schjeldahl saw "an artistic disaster." Without "a consistently maintained, compelling fiction in the photographs' apparent point of view . . . there seems reason to doubt that he ever fully knew what he was doing." Stuck with his original characterization of Levinthal's hip moves, Schjeldahl curdles when he detects the betraying odor of "sincere" feeling in the work. Since he never saw it in the first place, he won't let Levinthal "exalt . . . personal (middle-class, chickenshit) fears, angers, and self-loathings." It doesn't fit. The photographer can't have "his cake of effrontery and upchuck it too." That the photographer has always taken deep-play and all the contradictions and responsibilities that it implies seriously seems to have escaped the critic entirely. **58.** Garry Trudeau, "Afterword," in *Mein Kampf*, David Levinthal (Santa Fe: Twin Palms Publishers, 1996), 84. Trudeau's statement, appearing in a work that would be received with much ambivalence, was prescient. See Schjeldahl, "Down in Flames," quoting Mel Brooks's *The Producers* ("Talk about bad taste!),") 90. When Trudeau wrote, "The child-artist with his toys expects the rest of us to act like grown-ups," he wasn't excluding critics. **59.** Schjeldahl, "Down in Flames," 90. **60.** "Today I shall tour the stores . . . more books and toys for inspiration." *Journal*, March 22, 1984, 10:05 a.m., 45. The journals, full of self-recrimination reflected on his need for toys well after *Modern Romance* was completed, not surprisingly, since all the subsequent projects included them as well. "I wonder how much I could do if I ever tried working all the time, building models or otherwise trying to be productive. Perhaps that is why I am constantly buying new toys; it is a way of feeling alive. *Journal*, August 26, 1991, Northampton, 285. **61.** Charles Baudelaire, "A Philosophy of Toys," *The Painter of Modern Life and Other Essays*, translated and edited by Jonathan Mayne (London: Phaidon Press, 1964), 199. Richard B. Woodward was the first to explore the philosophical connection between the ideas of the French poet and the seriously playful activities of this photographer in "Toy Stories: David Levinthal and the Uncertainty Principle," in *David Levinthal*, 34-44. **62.** Conversations. **63.** Ibid. **64.** Ibid. **65.** Despite his New York-Jewish origins, he insists that he comes from a "mixed marriage": that is, when his mother, Rhoda

friend, his mother named him David Lawrence (Levinthal) so that if he became a writer he could drop his surname. Conversation with Elizabeth Glassman, September 1999, Santa Fe. **66.** Once, at Allied Trains, a model-railroad store in Los Angeles, David noticed a little boy staring at him as he made his selections—he was buying a lot. The child turned to his father and said, "That's what I want to be when I grow up!" Conversations. **67.** Johan Huizinga, "Nature and Significance of Play," in *Homo Ludens: A Study of the Play-Element in Culture* (Boston: Beacon Press, 1955), 8-9. This classic treatment contains many considerations that effectively illuminate the philosophy behind David Levinthal's intentions and working methods. **68.** Eighty of these essays in articles, books, and catalogues are listed in the "Selected Bibliography," *David Levinthal*. **69.** Baudelaire, "Philosophy of Toys," 199. **70.** About making such images, David said, "Once the soldiers were down on the floor, I felt an explosion that hit a visceral nerve. I was carried away. Thought left me entirely." Conversations. **71.** Huizinga elaborates this in "Play and War," in *Homo Ludens*, 89-104. See also Roger Rosenblatt's introductory essay, "Levinthal's Camp," in *Mein Kampf*, 6-7. *Mein Kampf*, which explores the atrocities of Hitler through toys and lighting, is the legatee of his experiments in *Modern Romance*. Rosenblatt states, "Until Levinthal created *Mein Kampf*, I never understood how his toy figures operated. They toy with us. . . . [T]hey present moral and aesthetic problems. In a way they are united against us. They needle us, as if to say, 'We are the figures, but you have to figure it out'" (7). Implicit in Levinthal's *Mein Kampf* is the kind of summation that Guy Davenport describes in "Civilization and Its Opposite in the 1940s," in *The Hunter Gracchus*, 76-102. "There was a public forties in the history of the arts, and there was a secret forties" (94). **72.** Baudelaire, "The Painter of Modern Life," in *Painter of Modern Life*, 8. Based on an essay written in 1859 and 1860, it was first published in late 1863. **73.** Baudelaire, "Philosophy of Toys," 198. His emphasis. **74.** Conversations. **75.** Ibid. **76.** He attended Yale from 1971 to 1973. Accepted in the spring of 1971, he began bleeding heavily and had to be hospitalized. For the next thirty years he was medicated for colitis with two cortisone enemas a day. **77.** Painter-printmaker Philip Taaffe, in an interview with film-maker Stan Brakhage, in *Philip Taaffe: Composite Nature* (New York: Peter Blum Edition, 1998). Brakhage prefaces the remark with, "The arts need it to bust open into new areas, just like people need the embarrassment of their teenage years." Both statements are on page 65. **78.** According to American collector Alex Shear, "If you want an evocative depiction of our culture at this stage in our history . . . don't go to an art museum—look in your refrigerator." See David Owen's profile of Shear, "The Sultan of Stuff," *New Yorker*, July 19, 1999, 61. Gathered for over thirty-five years, among Shear's holdings, in "more than twelve hundred categories," are "'station-wagon memorabilia,' 'folk-art roller skate carrying cases,' 'generator flash-lights,' and 'occupational hats'" (52). David Levinthal's extensive collections of models, toys, etc. often determine what he photographs. The amassment, while nowhere as vast as Shear's, relates to a similar obsession, as Owen observes, "to give a recognizable shape to a yearning that wasn't fully comprehensible even to him" (55). **79.** In a recommendation. Conversations. **80.** "How Do I Love Thee?" in *My Love* (New York: Marvel Comics Group, November 1973): 1, no. 26, pages unnumbered. Collection David Levinthal. **81.** *Kiss Me Deadly*, 1955, produced and directed by Robert Aldrich, starring Ralph Meeker as Mickey Spillane's detective, Mike Hammer. See *Film Noir: An Encyclopedic Reference to the American Style*, edited by Alain Silver and Elizabeth Ward, coedited by Carl Macek and Robert Porfirio (Woodstock, N.Y.: Overlook Press, 1979), 156-58. David Levinthal owns this encyclopedia. **82.** Conversations. **83.** Rather than citing the paintings of Hopper as anguished prototypes for Levinthal's scenes of *Modern Romance*, it is more useful to consider works like T. S. Eliot's "Rhapsody on a Windy Night," from Prufrock and Other Observations (1917). In the poem's meditations on a dark street past midnight, where "every street lamp . . . / Beats like a fatalistic drum," the words' twisted grimace of modernism highlight the layered psychological complexity intended by the photographer. See T. S. Eliot, *The Waste Land: Prufrock and Other Poems* (New York: Dover Publications, 1998), 10-12. **84.** Advertisement in *My Love*, November 1973, pages unnumbered. **85.** Eliot, *Waste Land*, 10. **86.** "Pocket Theater," in *A Wedding in Hell: Poems*, by Charles Simic (New York: Harcourt Brace, 1994), 37. Born in Yugoslavia in 1938, and now living in New Hampshire, Simic has explored his many experiences of popular culture in poetry. He has also pursued aspects of American art that parallel his own temperament. See *Dimestore Alchemy* (Hopewell, N.J.: Ecco Press, 1992), poems devoted to the work of Joseph Cornell. Simic's peculiar love of the sinister-small undoubtedly originated during his wartime experiences in Europe before settling in the United States. Space does not permit anything more than the citation of "Pocket Theater," here, but the poetic miniatures throughout his large body of work—from toy soldiers, to dolls, to walls and rooms and the eros of streets and stores—meaningfully parallel David Levinthal's working methods and imagery. **87.** The dramatic theory behind this is an old one. Appearing in the mid-eighteenth-century writings of Denis Diderot, it posed, through the complete absorption of a painted figure or figures, "in various actions, activities, and states of mind," the "supreme fiction of the beholder's non-existence." Paradoxically, the figures, in seeming to be alone without needing to be seen to establish this, grant greater intimacy to their drama. To be

known in a work of art, of course, they had to be seen by someone. But there is the impression, in certain pictures that Diderot viewed and commented upon, for example, by Greuze or Chardin, that their greatest possible effect doesn't depend on the viewer's gaze to complete their story. Rather by involuntarily, even helplessly, receiving the action or inaction, the viewer internalizes its emotion, thereby surrendering his own self-awareness. See Michael Fried, *Absorption and Theatricality: Painting and Beholder in the Age of Diderot* (Chicago: University of Chicago Press, 1980), 108-9. David wasn't thinking of Diderot or Fried. But the *Modern Romance* images convey a similar impression of the viewer not merely standing at a distance, but crossing the barrier between art and life, mysteriously absorbed into the scene of absorption itself. Fried quotes Diderot: "The immobility of beings, the solitude of a place, its profound silence" that suspends time; "time no longer exists, nothing measures it, man becomes as if eternal" (125). **88.** Camus, source uncited, in *Film Noir*, 4. **89.** He's seen scores of these movies and owns many on tape, as well as *Film Noir*, which catalogues and describes over three hundred of them, plus several books on the subject of film noir. See Rosetta Brooks's essay, "Shadowlands," in *American Beauties: David Levinthal*, exhibition catalogue (Santa Monica: Pence Gallery; and New York: Laurence Miller Gallery), 1990, 1-5, for a brief but perceptive attempt to characterize the effect of film on his work. **90.** Conversations. **91.** *Film Noir*, 77-78. **92.** Bachelard, *The Poetics of Reverie*, 145. **93.** *Film Noir*, 4. **94.** Ibid., 5. **95.** "Go-Between," 7. **96.** *Film Noir*, 4. **97.** Dialogue, not credited with a reference, and attributed to its film in the text or in an endnote, derives from the author's notes, taken during "*Film Noir* 99," a festival in Santa Fe, New Mexico, July 9-15, 1999. **98.** *The Asphalt Jungle* (1950). **99.** Ibid. **100.** *Kiss Me Deadly* (1955). **101.** *They Live by Night* (1948). **102.** *Murder My Sweet* (1944). **103.** *Out of the Past* (1947). **104.** *They Live by Night* (1948). **105.** *Out of the Past* (1947). **106.** Umberto Eco is explaining the necessarily precarious structure of films that become cult favorites in "Casablanca: Cult Movies and Intertextual Collage," in *Travels in Hyperreality*, translated from the Italian by William Weaver (New York: Harcourt Brace Jovanovich, 1986), 198. **107.** Ibid., 209. **108.** Advertisement in *My Love*, November 1973, pages unnumbered. **109.** David Levinthal, 106. While constructing the setups for *Modern Romance*, he kept the *Modern Romance* sketchbook beside the T.V. and recorded motifs he liked from films viewed on the VCR. They are a postmodern mix of film noir and other kinds of movies. *American Graffiti, Sorry Wrong Number, American Gigolo, I Want You Back Again, Strangers on a Train, Murder My Sweet, The Hustler, Desert Fury, Diner,* and *Taxi Driver*, specifically, are noted as sources. See *Modern Romance Sketchbook*, passim. **110.** *Journal*, April 20 [1984], 10:54 p.m., 71. **111.** Conversations. **112.** ". . . ideal material for an analysis of all the possible variants of the modern world." Jean Baudrillard, *America*, translated from the French by Chris Turner (London: Verso, 1989), 29. **113.** Conversations. **114.** "How Do I Love Thee," *My Love*, November 1973, pages unnumbered. **115.** *Journal*, April 20, 1984, 4:49 p.m., 69. **116.** Jean-Paul Sartre, *The Family Idiot: Gustave Flaubert, 1821-1857*, vol. 1, translated from the French by Carol Cosman (Chicago: University of Chicago Press, 1981), 32, 35. **117.** Ibid., 33. **118.** His mother has a dry sense of humor. Telephone Conversations. **119.** *Journal*, April 21, 1984, 9:53 a.m., 73. **120.** Philip Roth, *The Anatomy Lesson* (New York: Fawcett Crest, 1983), 144. **121.** Ibid., 132. **122.** See *Barbie Millicent Roberts: An Original*, photographs by David Levinthal, preface by Valerie Steele (New York: Random House, 1998), 5. David's faithful renditions of these dolls' glamour in no way diverges from the determination of the book's compilers to document the story of Barbie without any critical comment whatsoever. The very perfection of the images offers a vision of Barbie as a figure beyond herself. **123.** See Manthia Diawara, "The *Blackface* Stereotype," in *David Levinthal: Blackface* (Santa Fe: Arena Editions, 1999), 7-17. Diawara later concedes, but not without a hint of sarcasm. Concluding the piece, he describes an instance where his son shows him a picture of two laughing white kids holding slices of watermelon, as if directly mocking the black stereotype: "By bringing the image to my attention, my son made that much of an association. But his act is also challenging me to stop being the custodian of these stereotypes, to distance myself from them, and to begin to enjoy the humor in them. Only then will I like him, become an individual and modern" (17). **124.** "I am a lover in many respects." Conversations. **125.** *The Shifting Realities of Philip K. Dick: Selected Literary and Philosophical Writings*, edited and with an introduction by Lawrence Sutin (New York: Random House, 1995), 291. **126.** "But she is beautiful." *Journal*, June 3, 1989, 3:03 a.m., 221. **127.** Lewis Hyde *Trickster Makes This World: Mischief, Myth and Art* (New York: Farrar, Straus, and Giroux, 1998), 353-54. In the enclosed quote Hyde is quoting from Maxine Hong Kingston's novel *Tripmaster Monkey* (1989), 137. To explore the implications of what is only touched upon here would turn this long essay into a tract. Let us say, simply, that like those of Bachelard and Huizinga Hyde's text provides the richest and most resonant context through which to understand the work of David Levinthal especially as it moves into darker and darker realms.

THE END